PRESTEL
MUNICH · LONDON · NEW YORK

COFFEE STYLE

HORST A. FRIEDRICHS

Photography by Horst A. Friedrichs
Creative Direction & Design by Lars Harmsen
Text by Nora Manthey

COFFEE AS CRAFT

Coffee isn't what it used to be. A new culture is emerging, with innovators and artisans searching for the highest quality coffee possible with which to seduce us. There is care put into every detail: the origin of the beans, how they are roasted, and the finest way to prepare and present a cup of coffee. These "coffee people" love to talk about what they do, and how they do it.
So, let's talk *Coffee Style*.

WHAT IS COFFEE STYLE, and since when has coffee become so fashionable? Aren't we talking about that bitter drink waking us up every morning and getting us through the day? We are indeed, but there are those who believe that coffee is much, much more. That it is special. Call them coffee stylists. They treat coffee, or java, as it is also known, with the same reverence as others do fine wine. To be afforded such treatment, the product must be unique, and what is called specialty coffee is made of only the finest beans. These coffee enthusiasts are fashioning an artisanal product that, it would seem, we are now all too ready to buy.

These days we as consumers want to know about what we are eating, and both the quality and the source of our food have become of paramount importance. We now demand organic vegetables, home-made bread or even low-sugar lemonade. Coffee is no different.

And coffee stylists have answers. They know where their product comes from, who grows it and exactly what variety of bean goes into every cup. And they like to discuss what they know – both in person and online – in order to change our very concept of what coffee is. In the cafés, this starts with the signage and continues face to face with the baristas. They communicate the story of the coffee they serve, a story that begins at the origin and ends in the cup. In the virtual realm, these boutique operations reach a global community of coffee lovers. You can search for #coffeestyle to join them.

The scene we are looking at in *Coffee Style,* however, is primarily located in the cafés one finds in cities throughout the world. It is where baristas show off their skills and demonstrate their meticulous attention to detail. They do not simply make an espresso but aim for that ever-elusive and difficult to define "god shot", the perfect espresso. They do not simply pour filter coffee, they celebrate it. They do not use just any coffee maker but rather operate sophisticated apparatuses that were designed to impress.

But it is not merely show. *Coffee Style* searches for flavours one would not expect from coffee. In Italy, we found espresso smooth enough to roll around in your mouth; in London, filter coffee came dressed in the aroma of chocolate-coated strawberries; in Berlin, grapefruit and elderflower revealed an espresso's juicy body over ice; and black coffee with soda and cream brightened the day in San Francisco's foggiest neighbourhood.

The care and knowledge these baristas and entrepreneurs devote to the cups they prepared for us made it clear that this was going to be a revelatory taste experience. And it was. Once you go beyond the bitter beverage of old, there is no looking back.

Welcome to *Coffee Style*!

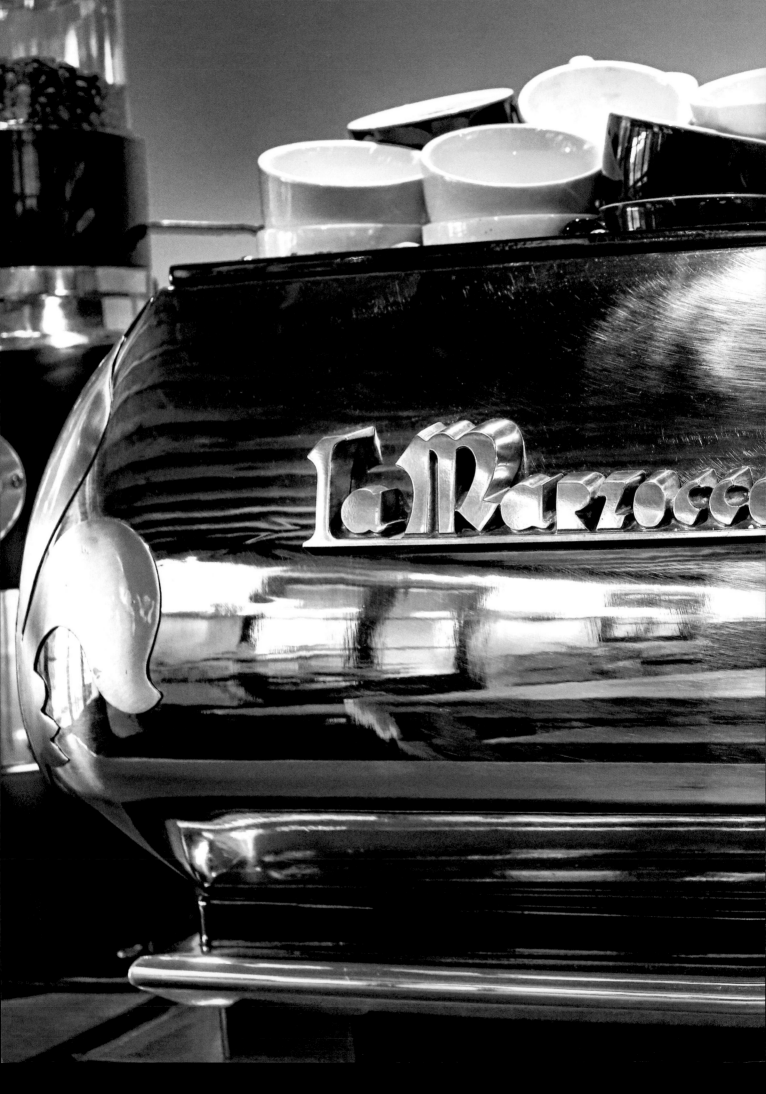

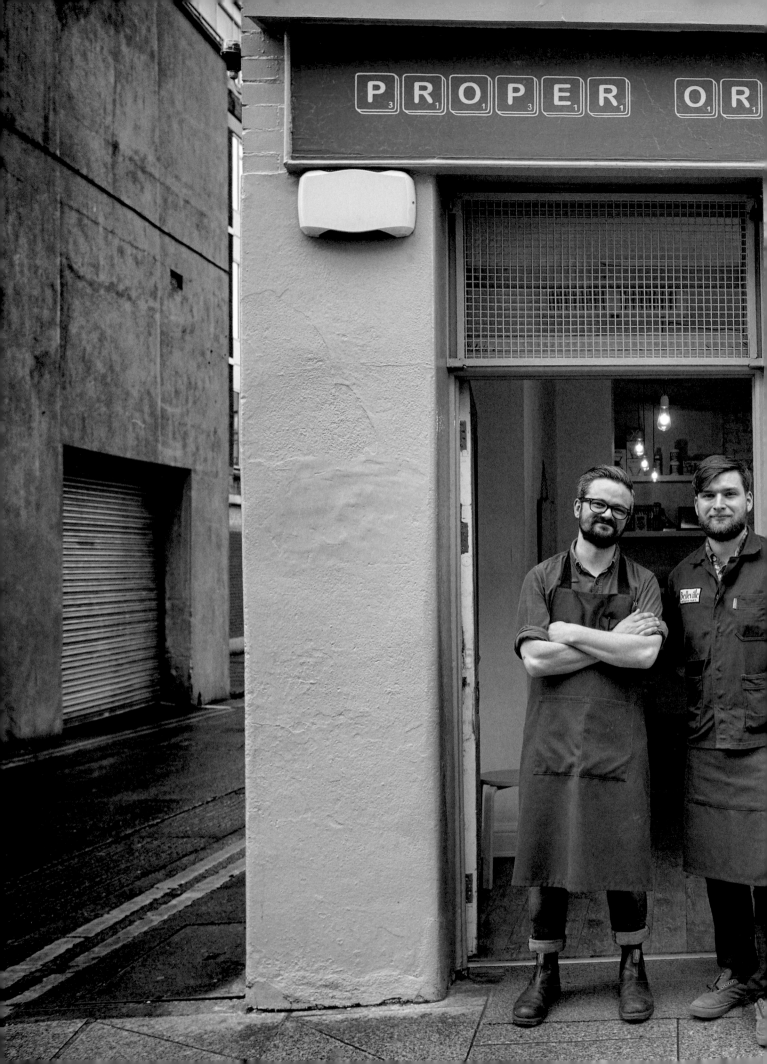

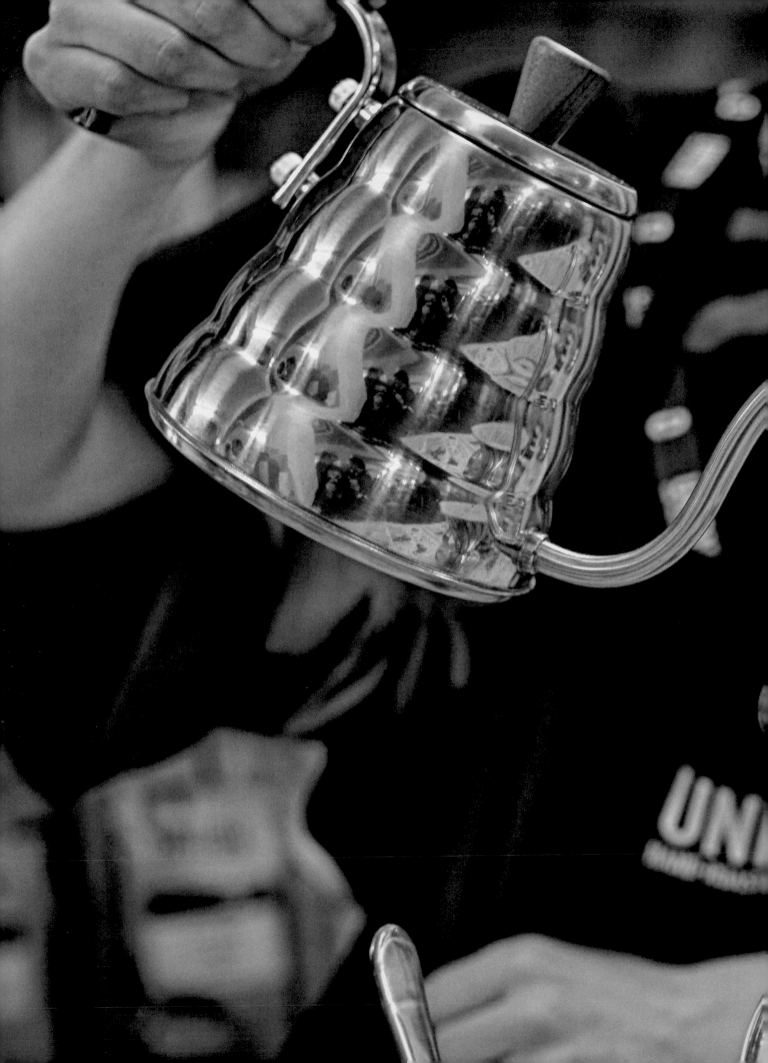

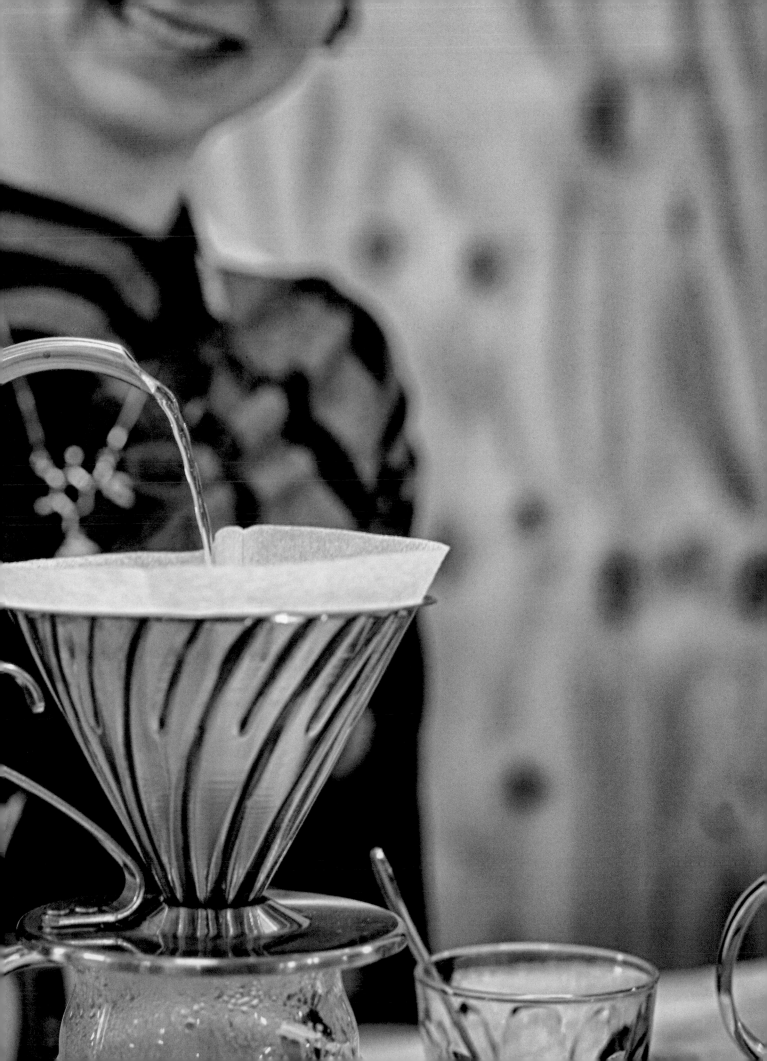

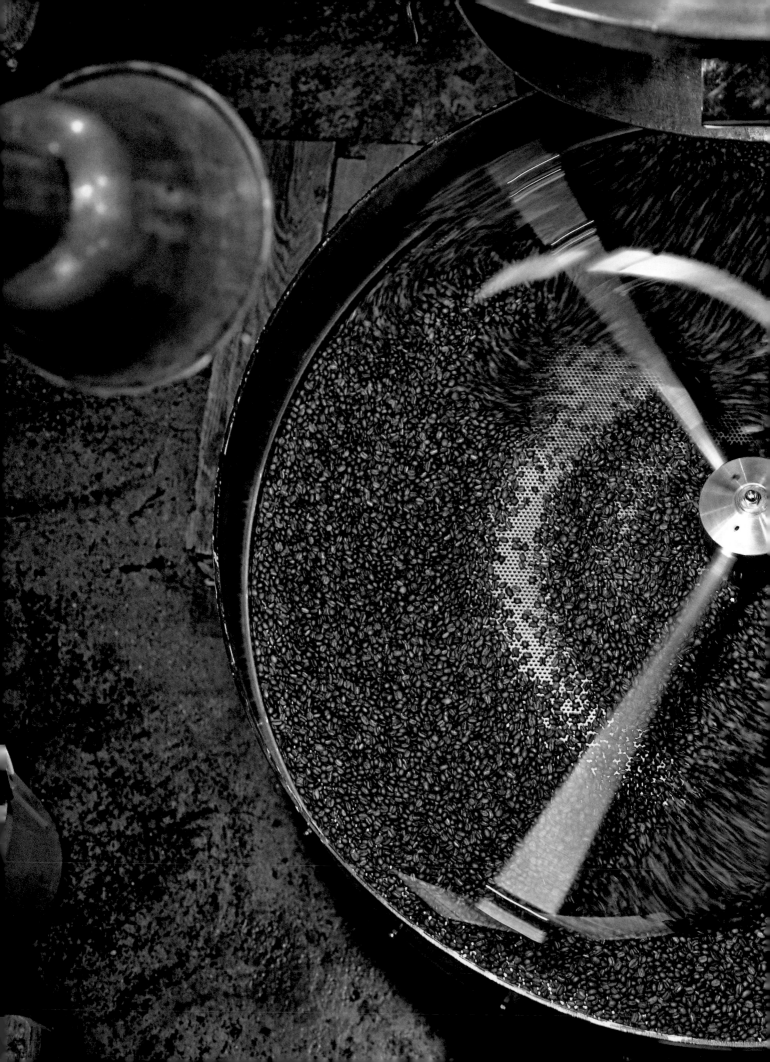

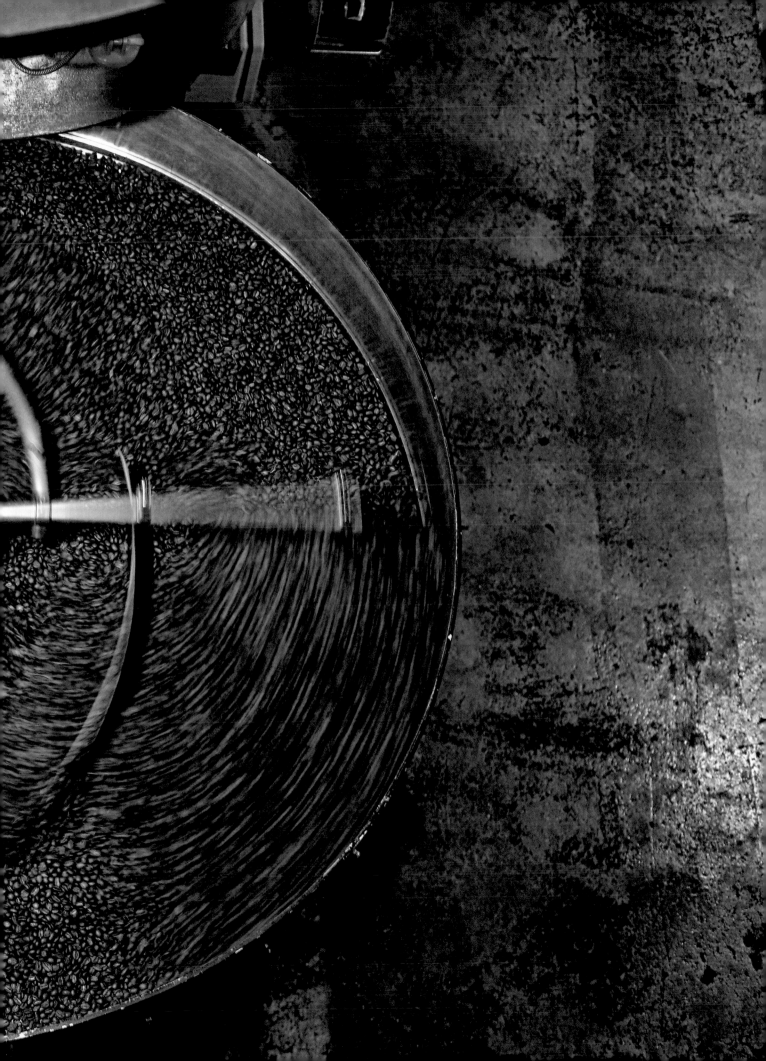

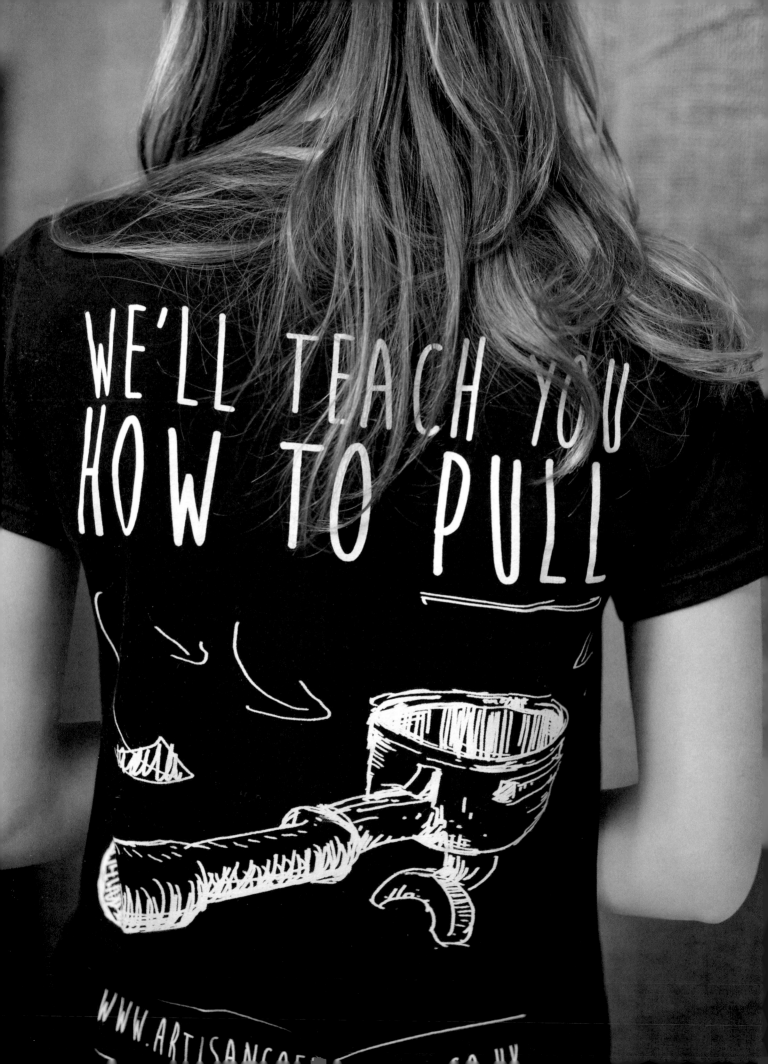

WAKING UP

SHAPING COFFEE CULTURE

Coffee in the twenty-first century is more that just a quick caffeine fix. It has become part of our lives – indeed a lifestyle. What was once a mass-market product is now a specialty item. So how did this happen?

The story of specialty coffee represents a small revolution. It is a revolution that developed in three waves and that has changed coffee culture forever. The scene has its genesis in the late 1960s, in California's Bay Area, lodged between green hills and the blue Pacific, an area rife with opposition to the status quo. People were widening their horizons, looking differently at society, and coffee too was swept up in this era of change.

Coffee has long been a part of modern life. With innovations such as vacuum packaging and instant coffee, coffee became widely available and thus a broad commercial success. With the advent of modern advertising after the Second World War – during and after which coffee was traded on the black market – and particularly with the power of television, the post-war economic boom witnessed the development of a true coffee culture, and the beverage was widely consumed each and every day.

The only demand by consumers was that coffee be readily available and that it be cheap. Traded on the mercantile exchanges of London and New York, coffee arrived to the West in containers stuffed with Robusta beans, a variety that delivers what its name implies: robust plants that are high in caffeine. It was a quick fix.

And while today the mass-market industry is essentially unchanged, it was disrupted in the 1960s, when Northern California produced the first wave of specialty coffee.

The movement started in Berkeley, with Alfred Peet, the son of a Dutch coffee roaster, who, tired of the poor-quality product then popular, sought to introduce the better-tasting coffee he remembered from his youth in Europe. So he imported high-quality beans from faraway places and roasted them in small batches. At his retail shop, Peet's, the Arabica bean established a foothold in the United States. While the Arabica species is richer in flavour than most Robusta beans, its cultivation requires greater care and is thus more expensive. It is the foundation of the specialty coffee that, during the next wave of its evolution, would become a global phenomenon.

The second wave took off in the 1980s, in Seattle, the home of Starbucks. The first owners originally bought their beans from Peet's, and later expanded their business into a global chain with cafés in every metropolis in the world.

In the United States, Starbucks' cafés introduced a public weaned on soft drinks to a whole range of espresso-based beverages. Instead of popping out for a Coca-Cola, people began to "go for a cup of coffee". And the media helped to create this new image. Soon, to-go cups began to appear in Hollywood movies, and coffee shops featured as settings for TV sitcoms such as *Friends* or *Ellen*.

Coffee went from being a simple part of everyday life into an experience lifestyle with flavour, and this phenomenon spread throughout the world. Coffee-dedicated shops began appearing in urban centres, not all but many of

them Starbucks, which grew into a corporation not unlike the coffee industry's big players – the very companies specialty coffee first took on. But coffee culture was soon to experience another transformation.

The third wave certainly owes a great deal to the transformations that preceded it. Peet's and Starbucks had opened the market for a new generation that then took the coffee culture a step further.

This new generation made specialty coffee even more special, forging closer relationships with growers and becoming more savvy in selling their product. They began to source small batches of coffee and introduced changes to the style of roasting. Moving away from the so-called espresso roast in which the beans reach a dark brown colour providing a predictable and consistent taste, a more gentle roasting was used to preserve the diverse flavours within the bean. Variety was thus added to the mix.

The difference is best noted in filtered coffee. But we are not talking about the traditional machine-filtered cup. Rather cafés began to feature a so-called slow bar: a stage for an array of drip cones for hand-poured filtered coffee and for captivating conversation with well-informed baristas. Stumptown and Intelligentsia, cafés in Portland and Chicago, respectively, are largely credited with this new celebration of coffee. Coffee shops became locations with backstories, their employees "rock star baristas". In the new millennium, making, talking and tasting coffee has become a cultural experience.

The coffee style we are looking at today represents in some sense a step back. While the brand and the preparation of a cup are still a large part of the story, the new stars of the scene are the producers. There is a renewed respect for the agricultural product: "Calling coffee by its first name", as Peter Giuliano, former director of coffee at Counter Culture Coffee in Durham, North Carolina, put its. He was at the forefront of the trend of buying coffee directly from farmers, a type of fair-trade model but with higher prices for growers and, consequently, for consumers. This cost increase had to be explained, and it thus became part of the story.

The story of coffee naturally begins at its origins, but it is ultimately recounted in homes, cafés and roasteries, where custom-designed stickers and informational material accompany the different bean varieties. We are speaking generally of single-origin coffees, in other words coffee from a single region or even a single collection of beans. The labels typically identify the name of the grower, the altitude of the farm and the harvest process. Buying online, one can find a coffee produced at 1,400 metres by the Ejo Haza Women's Group in the Rutsiro region of Rwanda. Compare this to a bag of supermarket coffee that simply gives the origin as Brazil – what we have is quite a different story.

While one may ask why this information is important, the implications are considerable. For one, this is a good indication of quality. As a rule of thumb, the higher altitude the farm, the better the coffee. And small batches from small plantations promise exclusivity. But ultimately, the story behind the production stirs one's imagination: just imagine an all-female collective of civil war survivors who grow their own coffee.

It is this sort of storytelling that makes specialty coffee so attractive to modern consumers. It transforms something as commonplace as coffee into a product with a history and, as its best, an ethical backstory. It introduces new flavours to us, and it is personal – at the heart of this global movement are people who make, serve and love exceptional coffee.

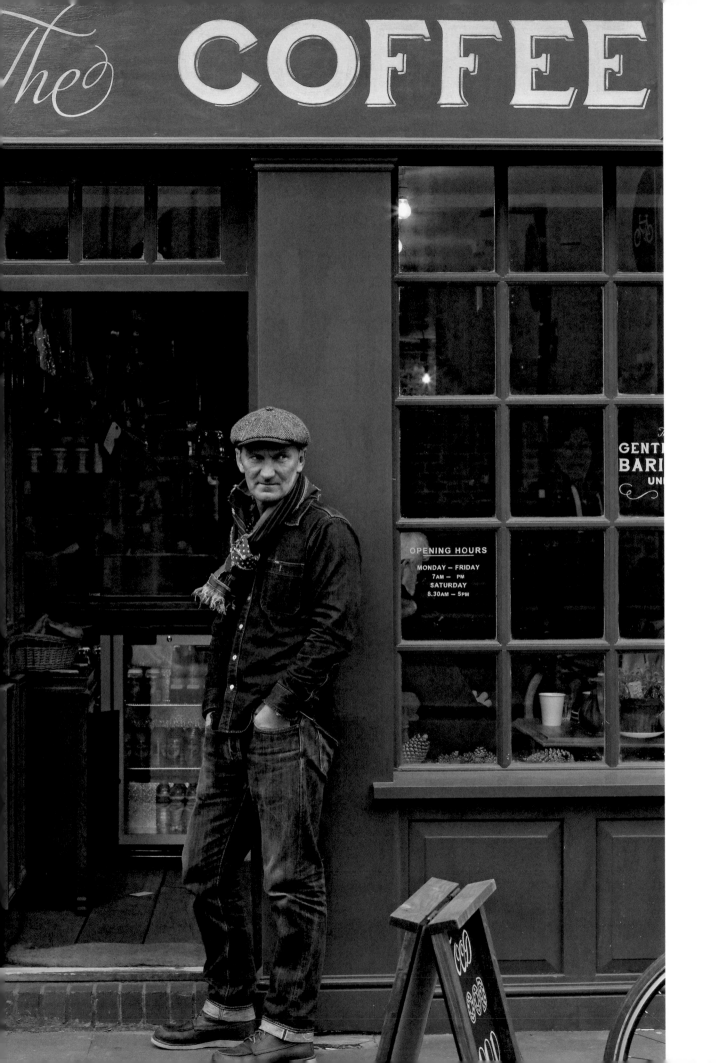

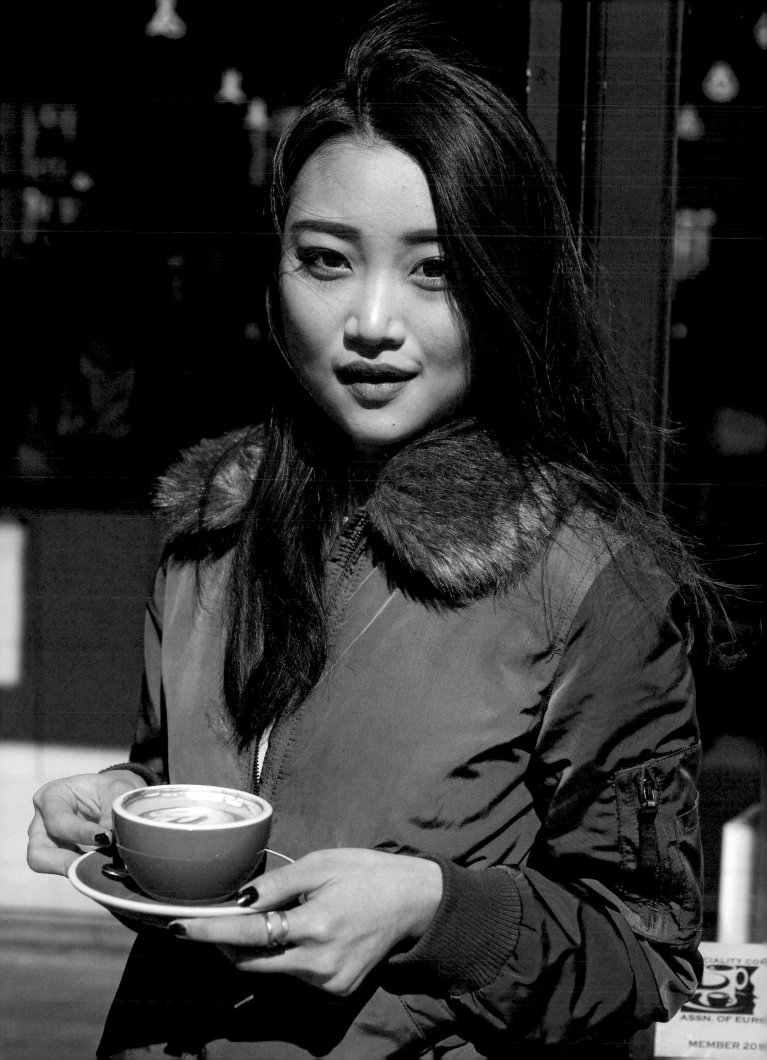

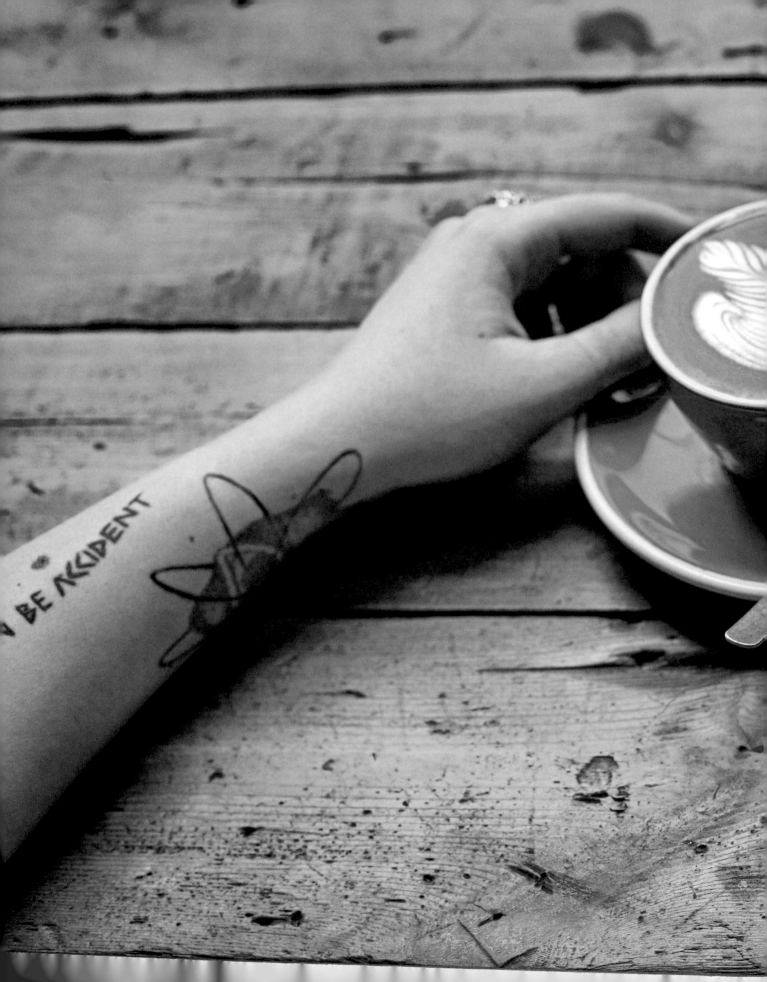

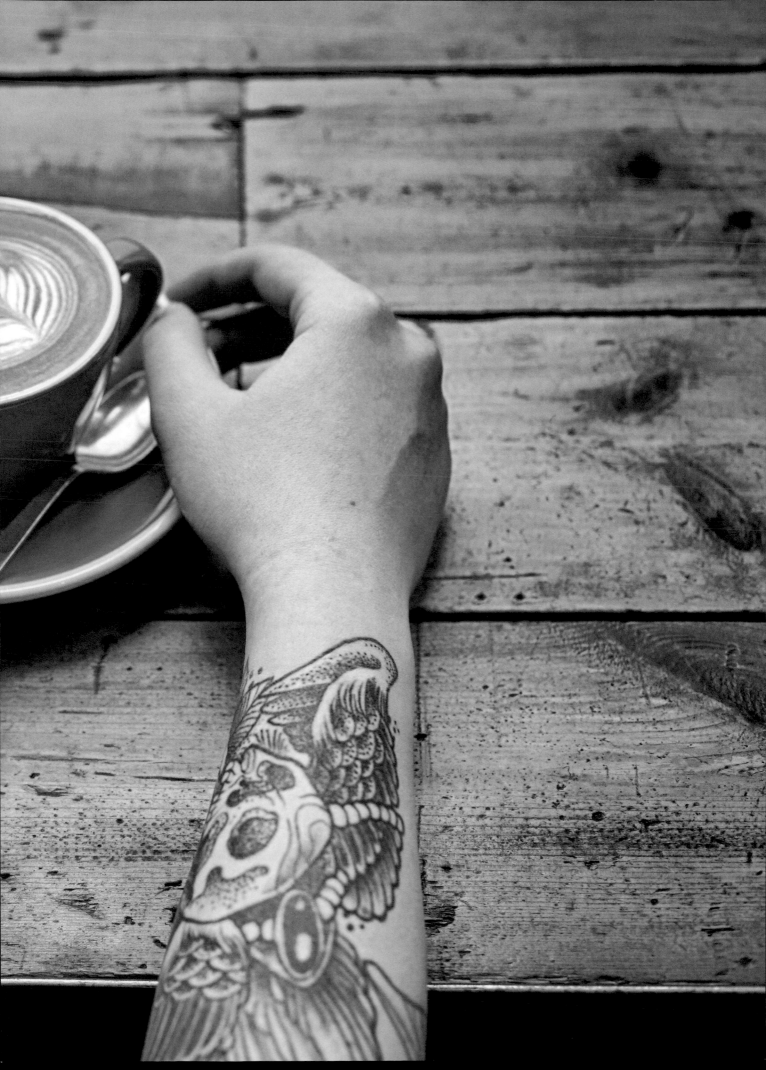

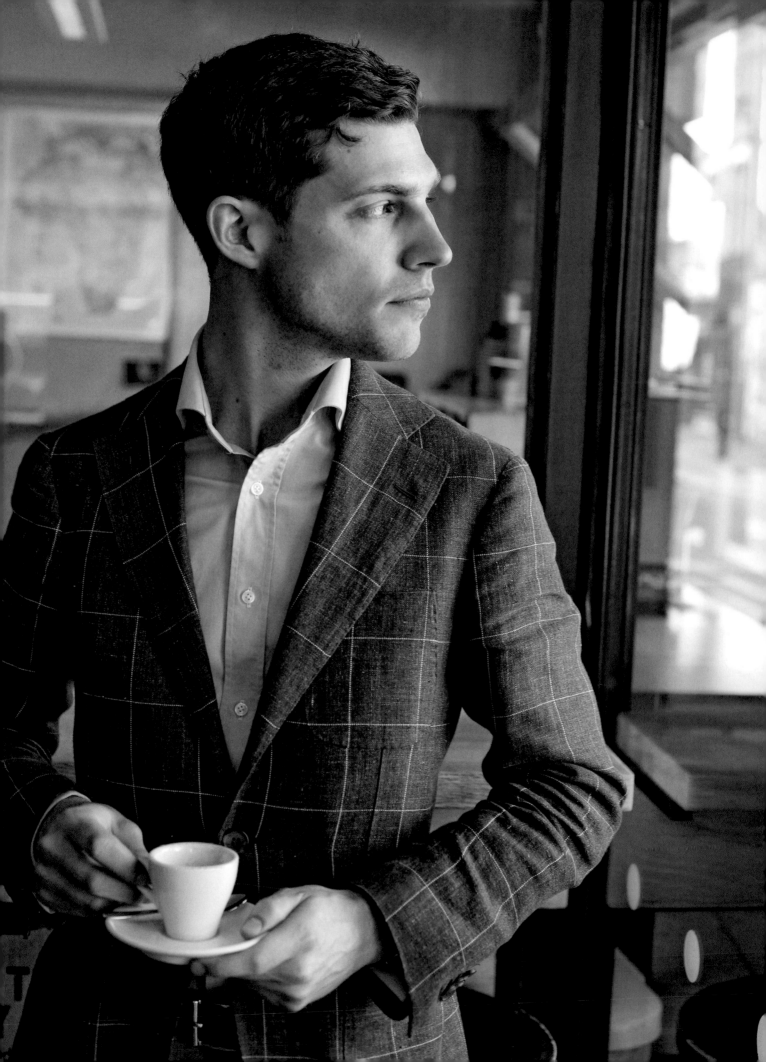

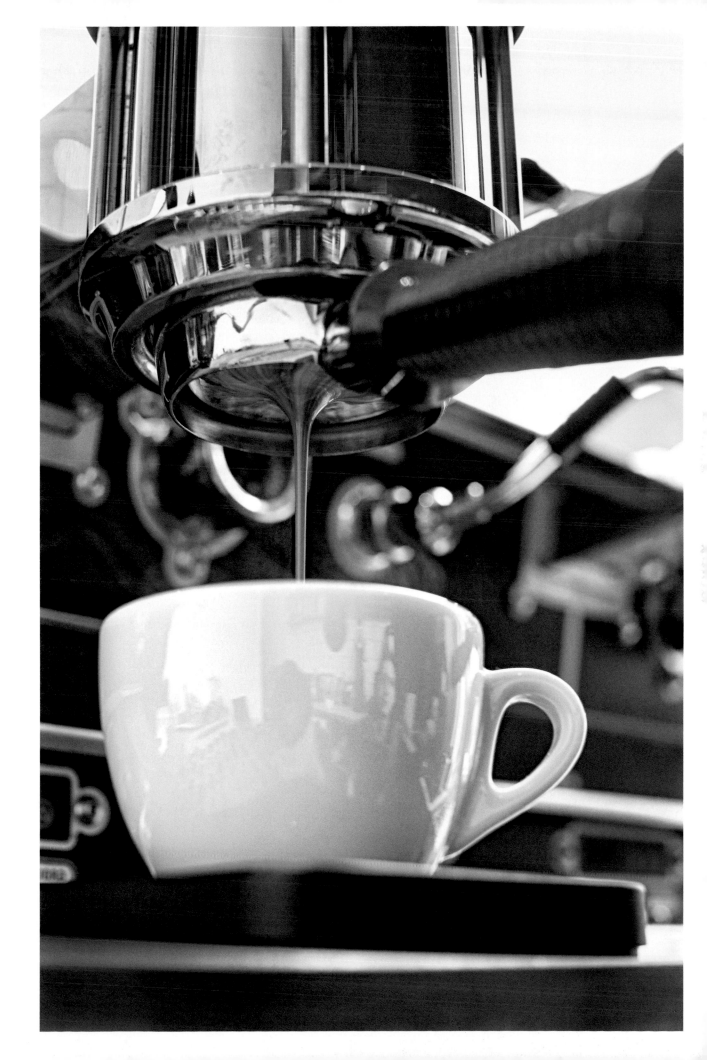

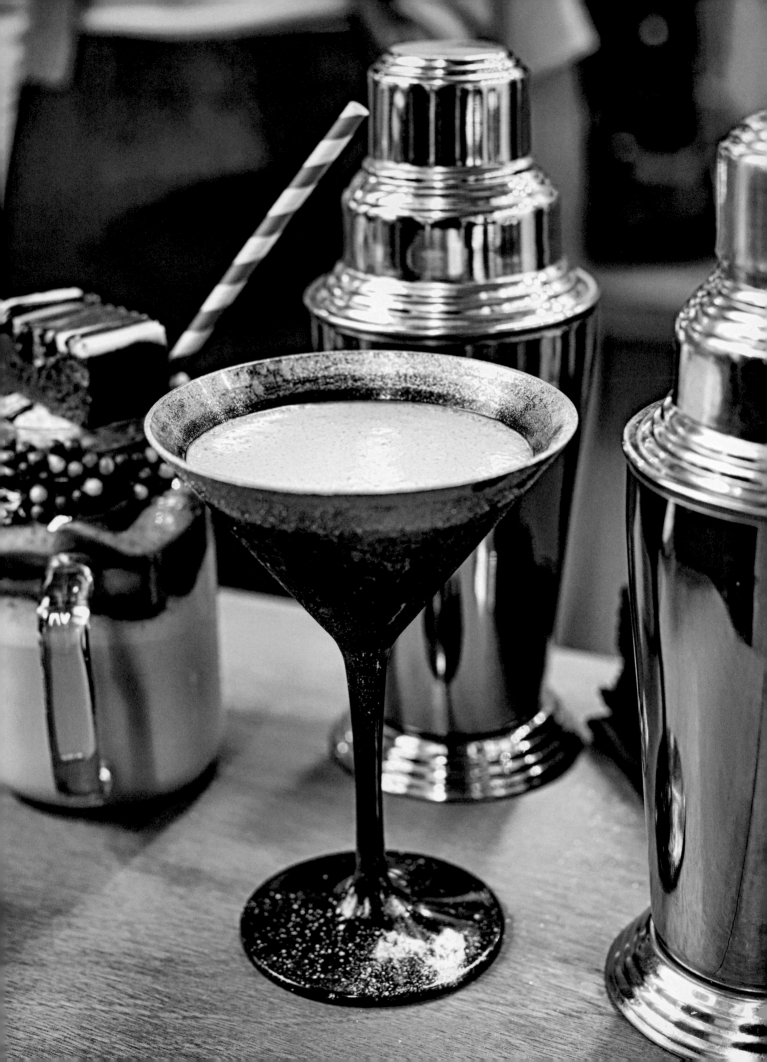

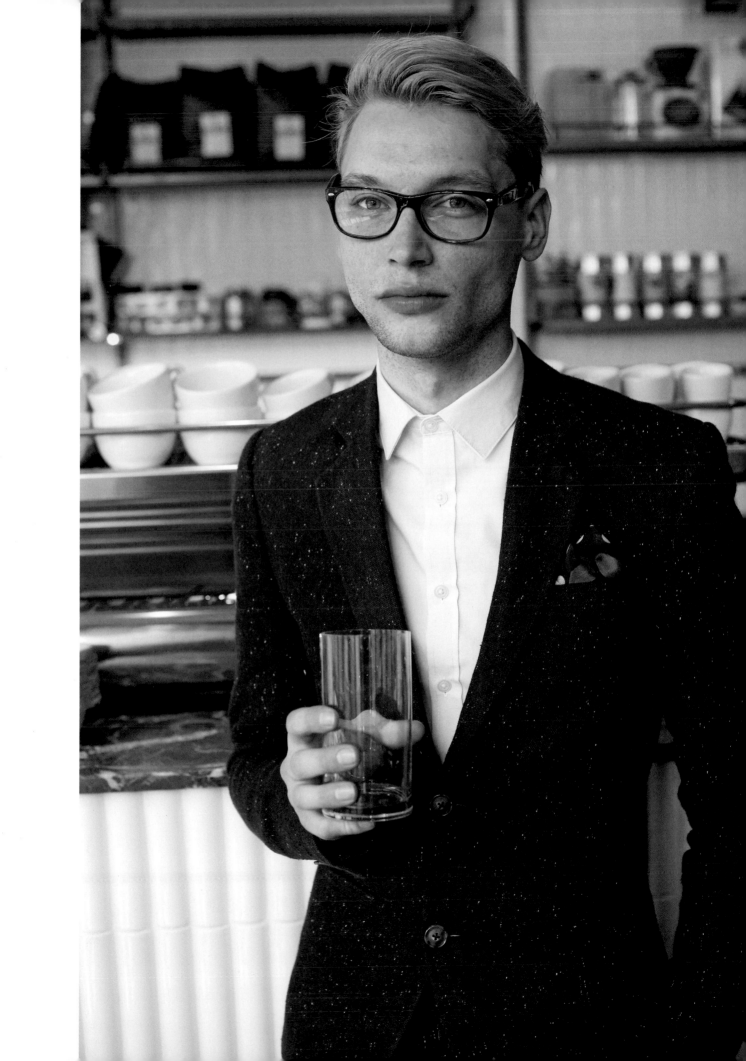

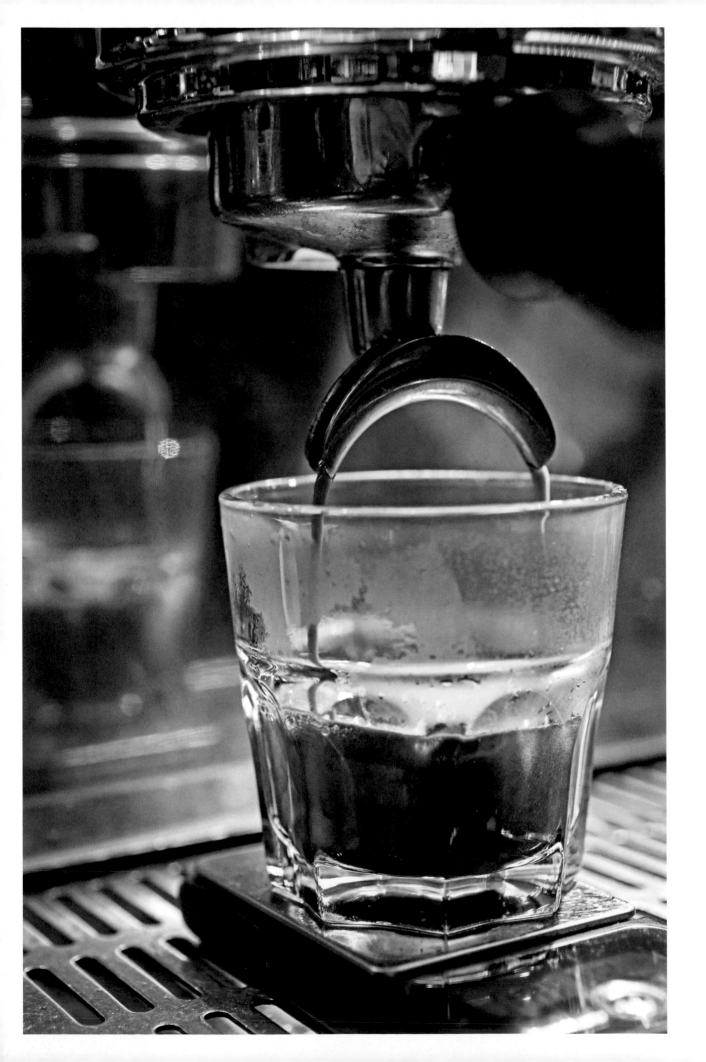

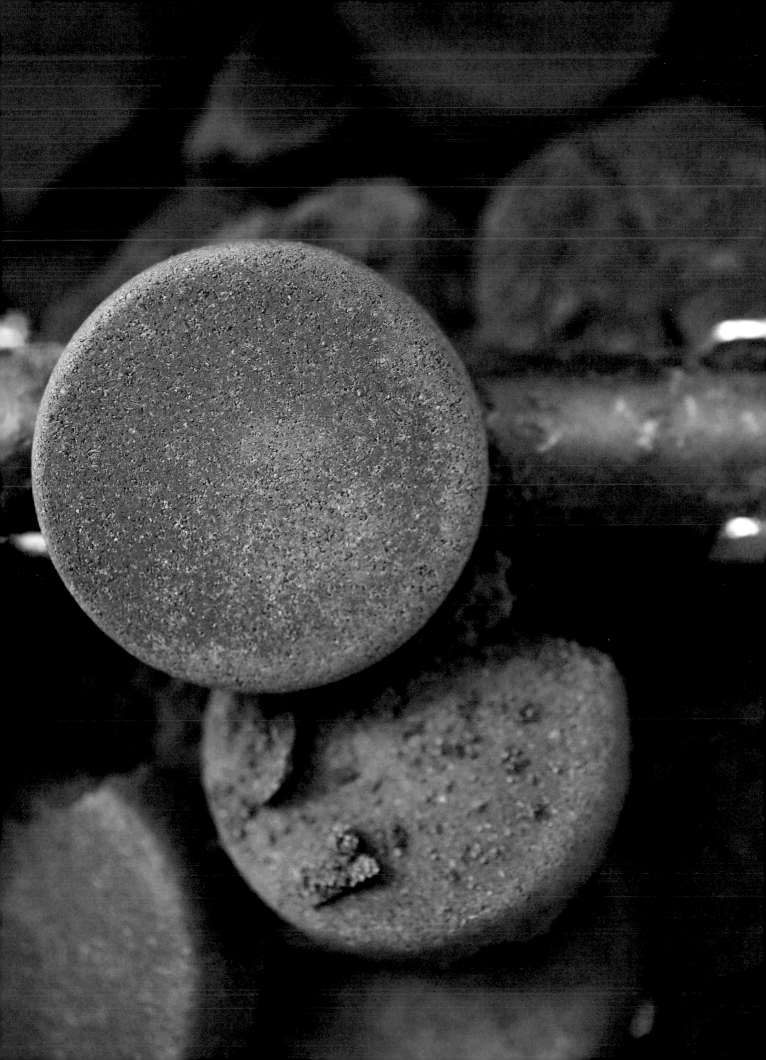

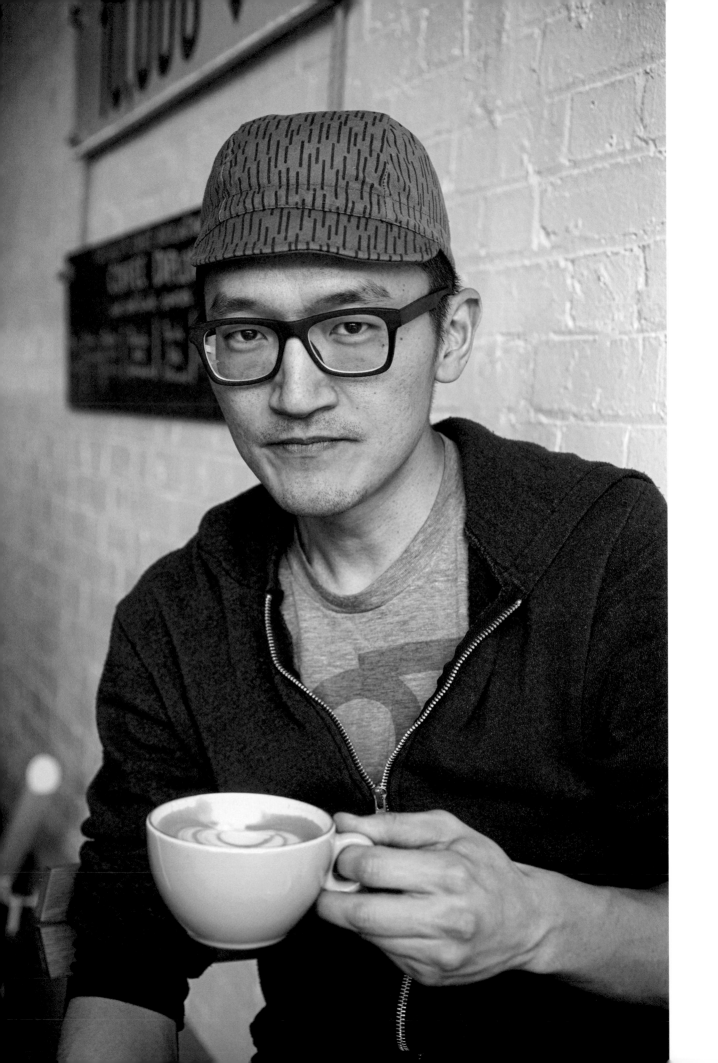

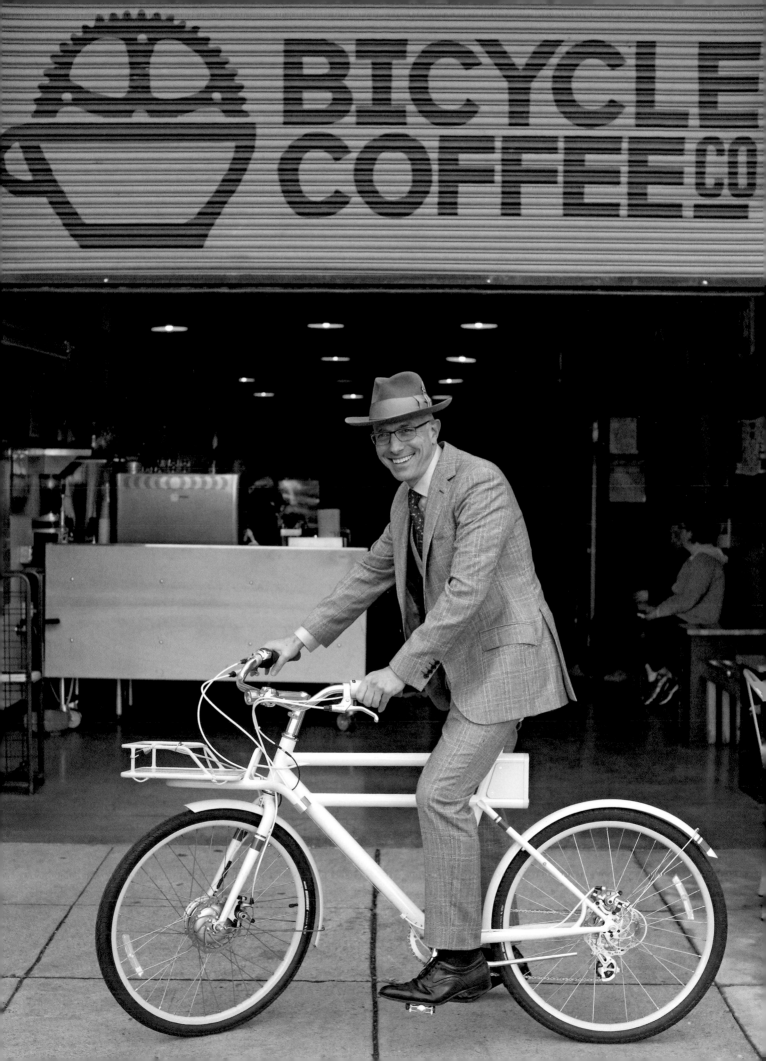

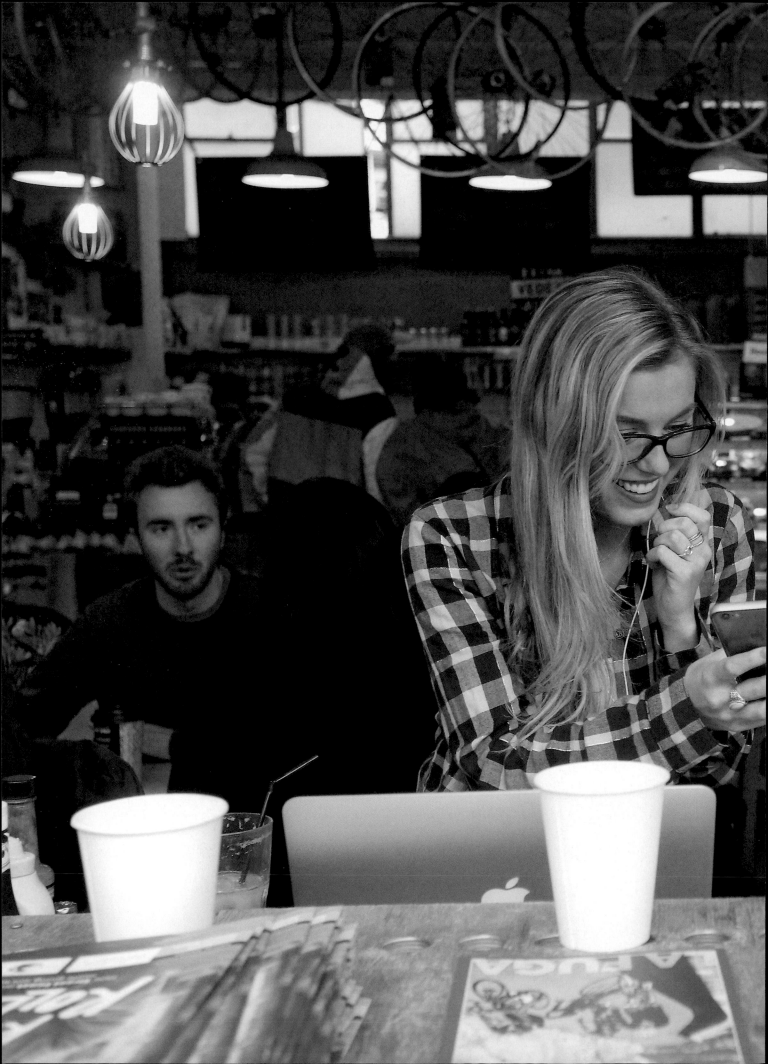

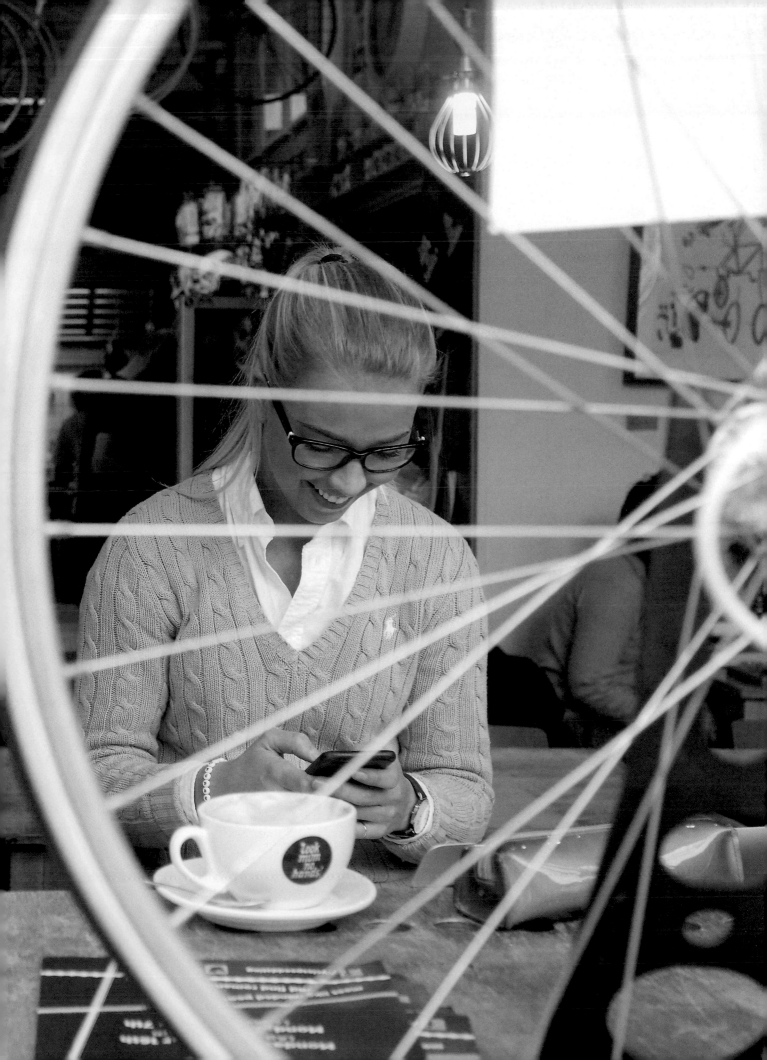

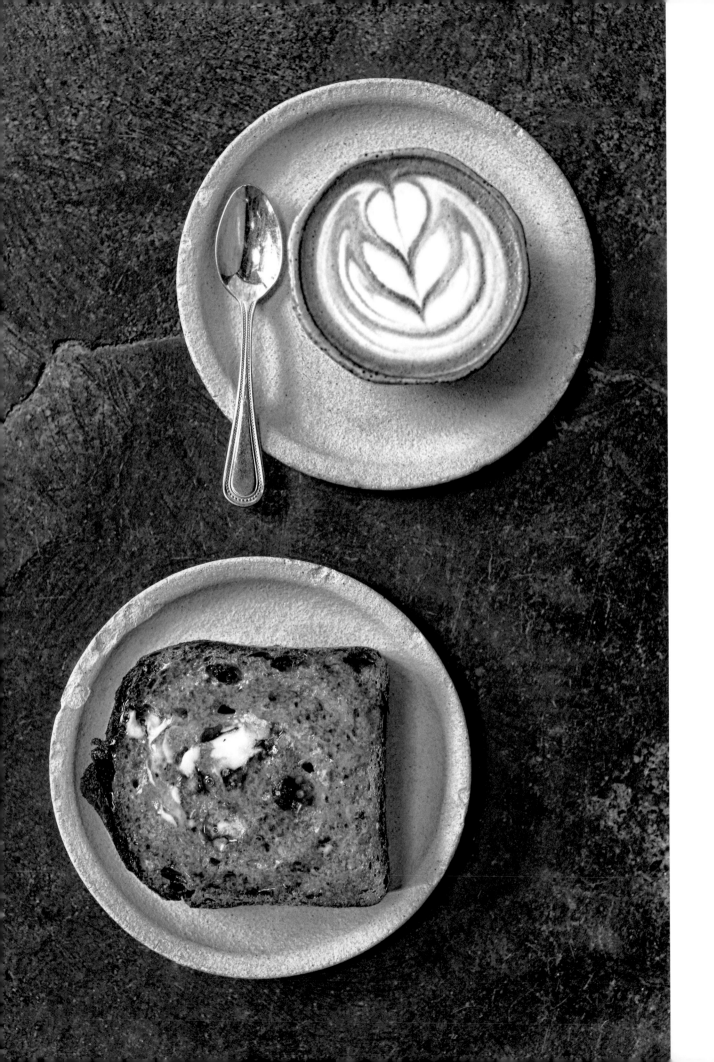

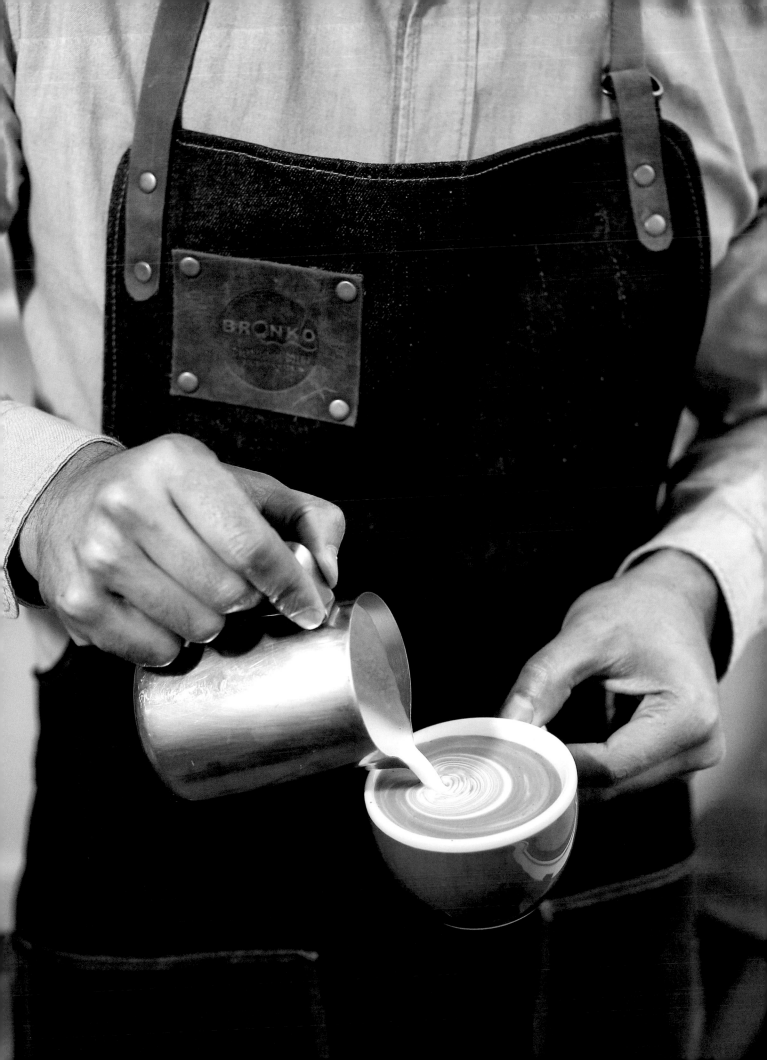

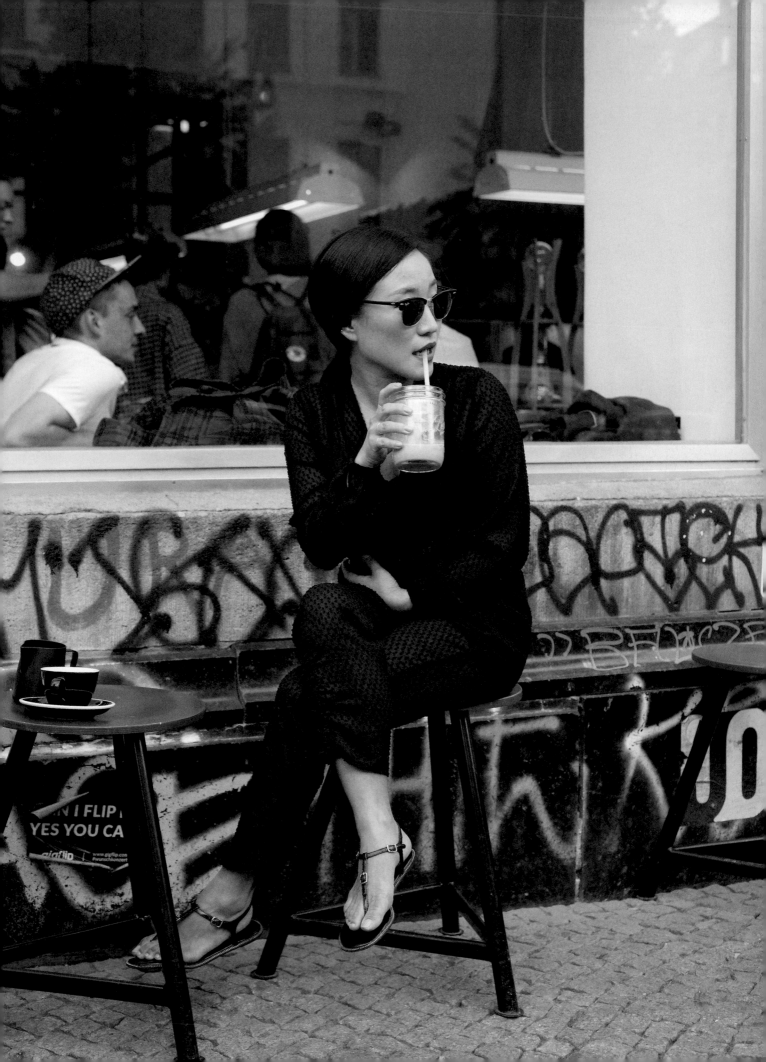

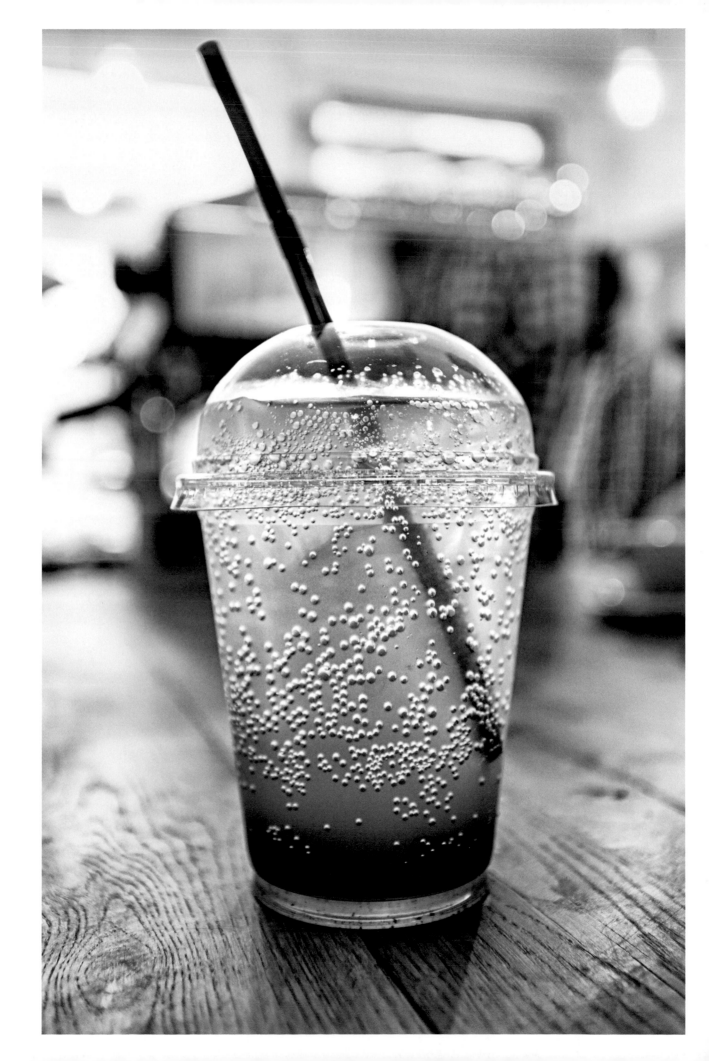

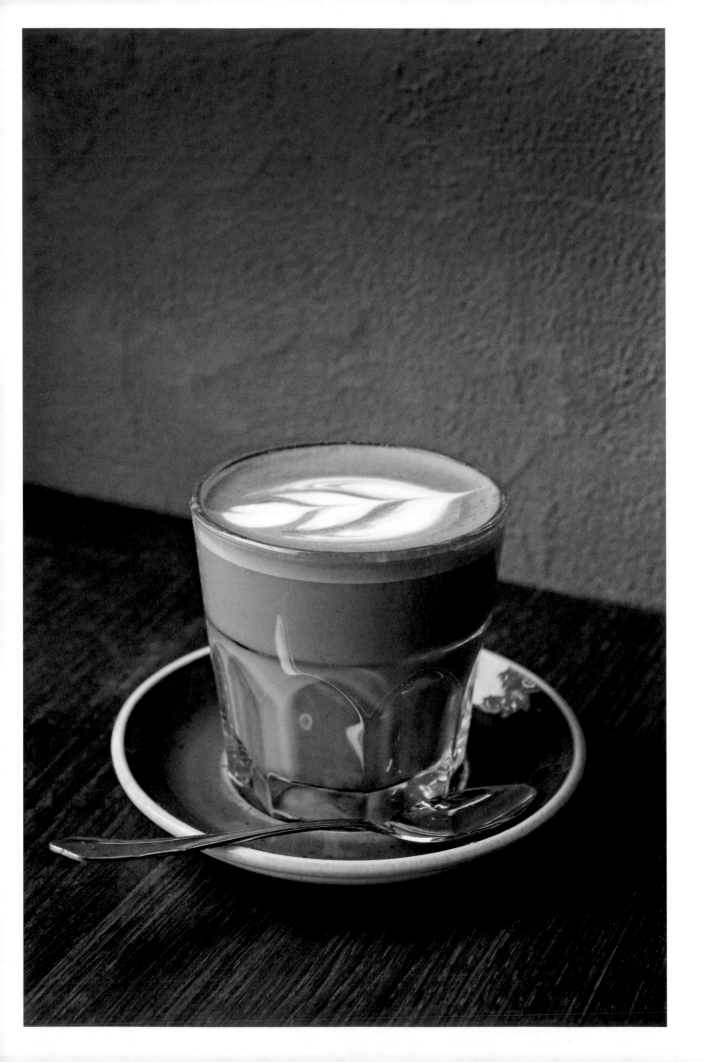

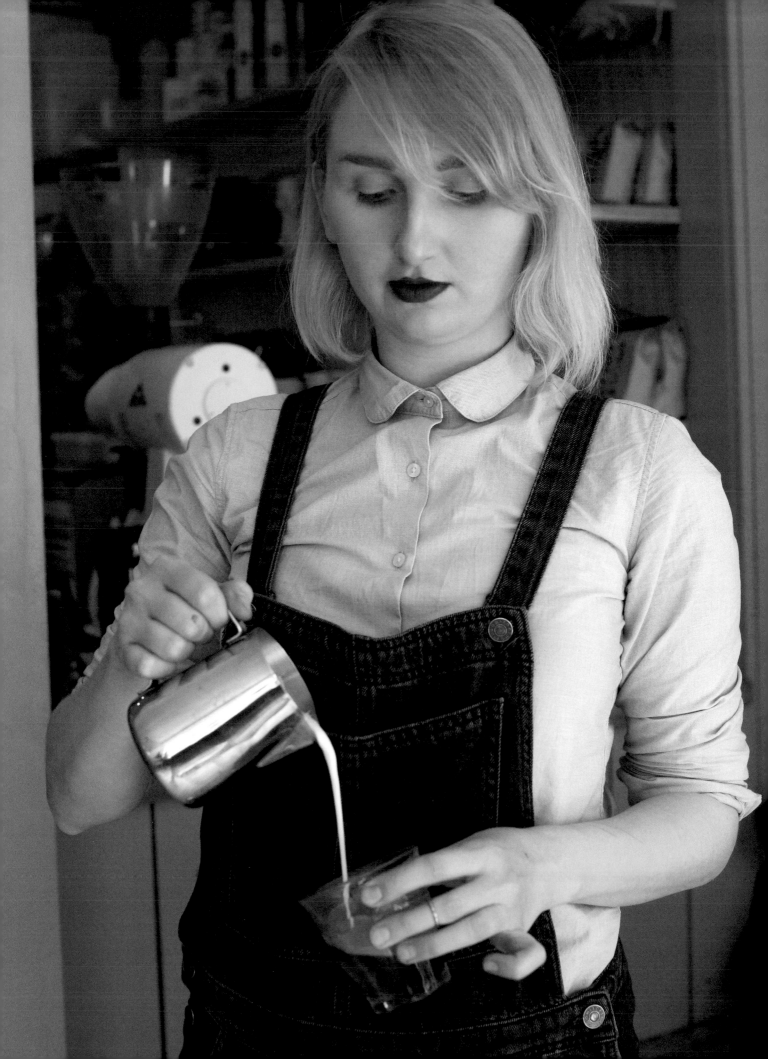

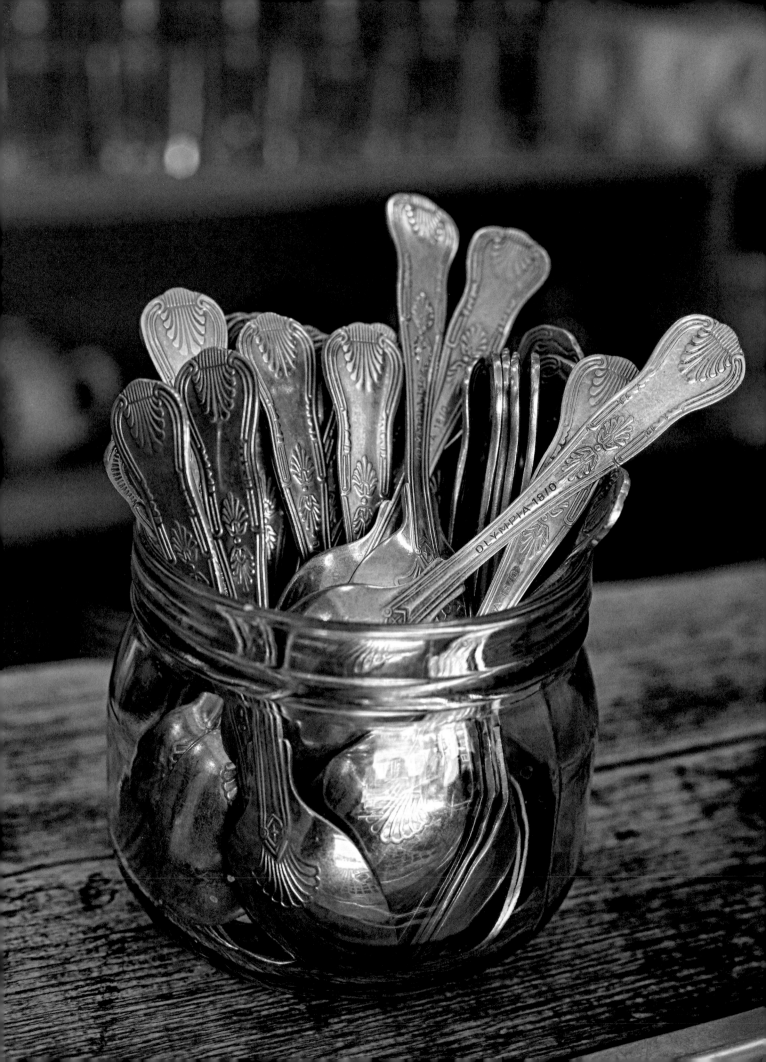

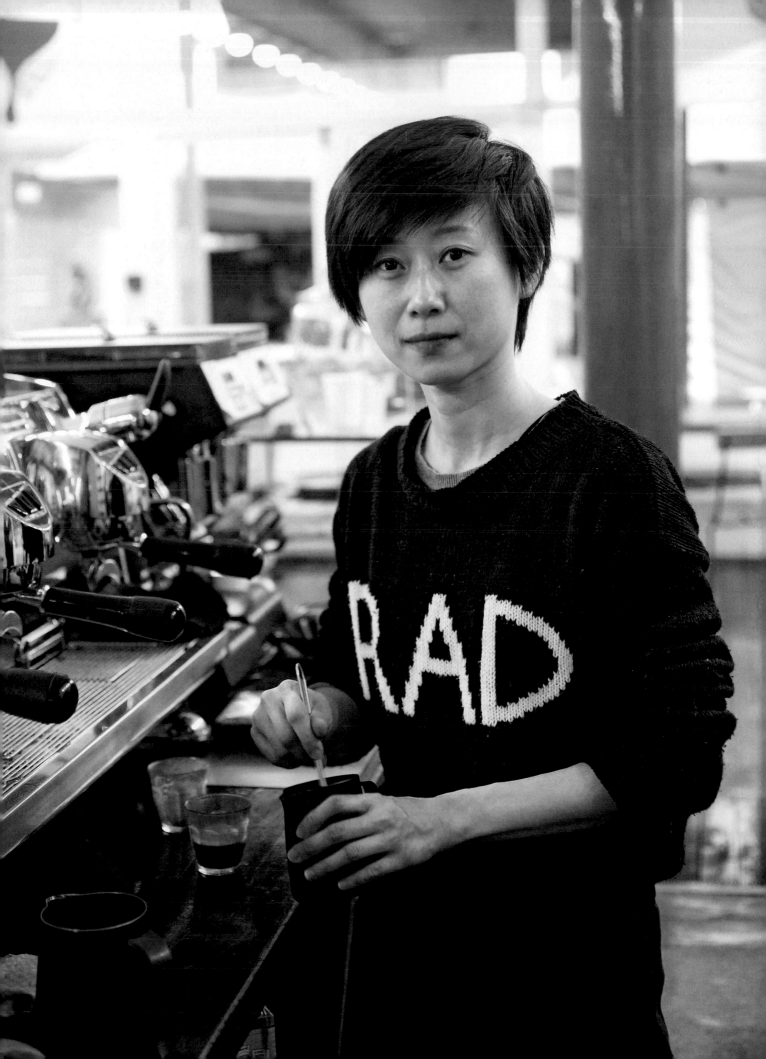

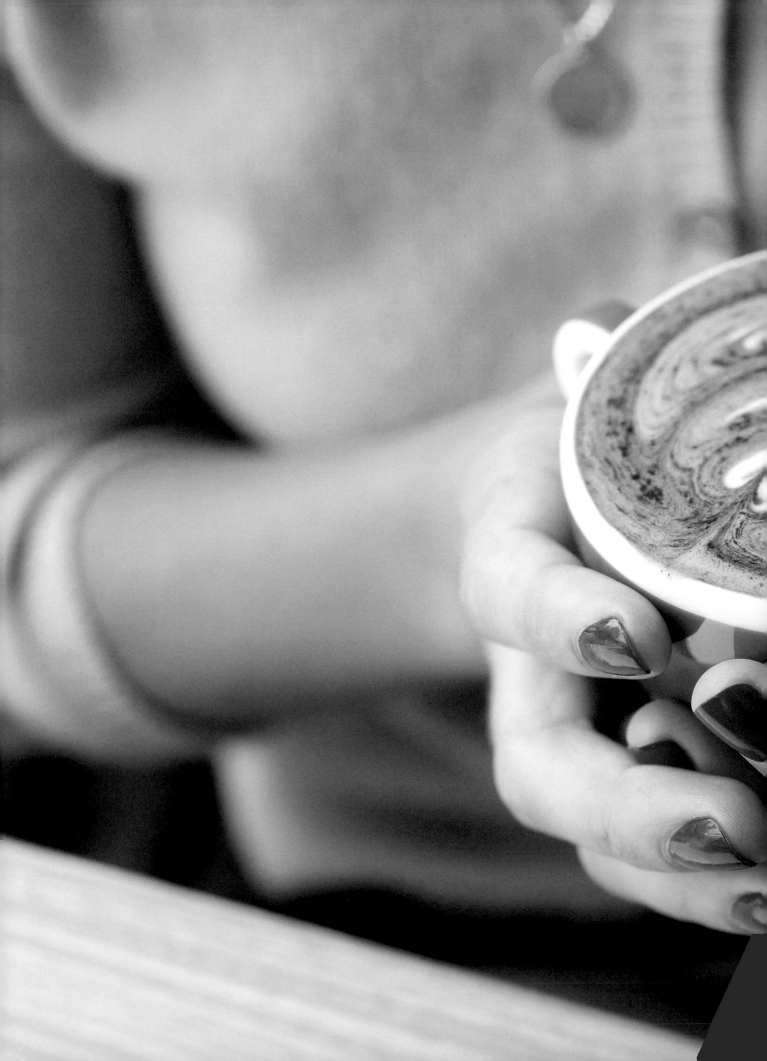

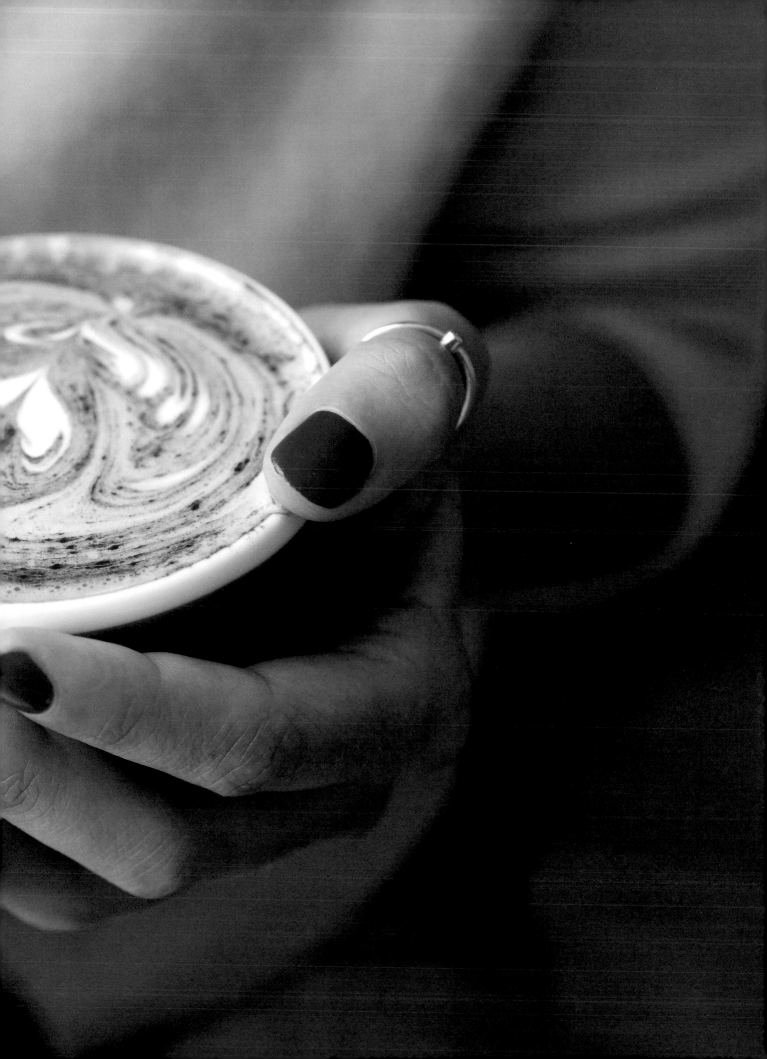

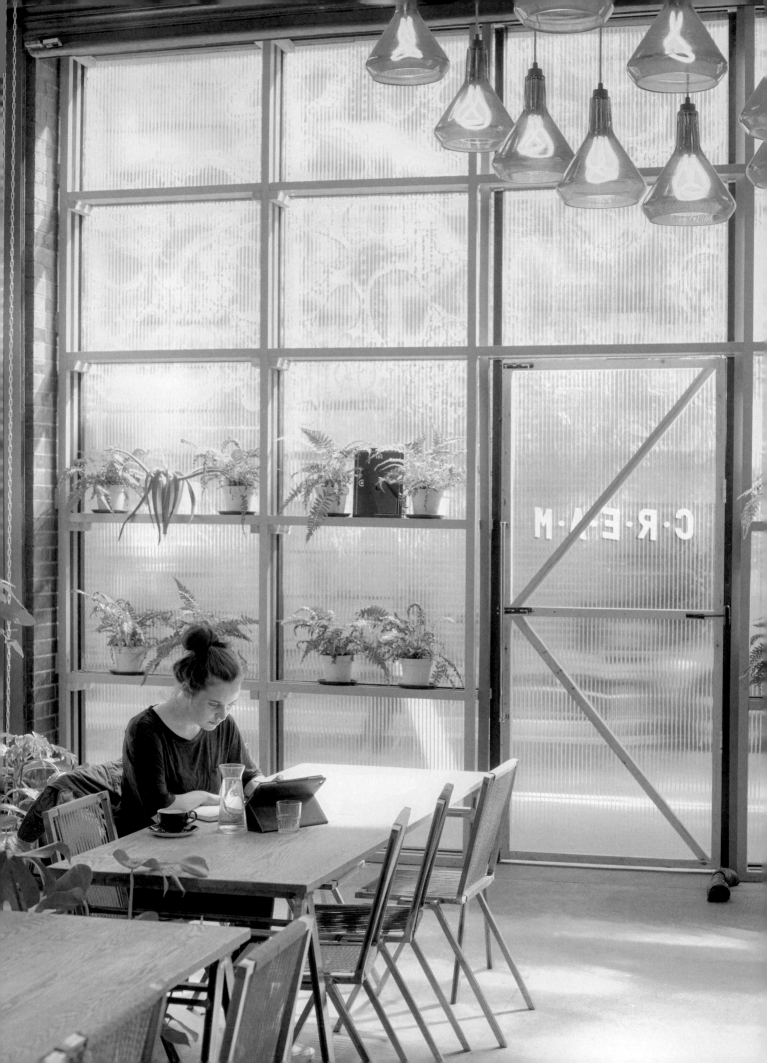

GLOBAL LOCALS

CONNECT AND CREATE

Coffee Style takes place inside in the cafés found in every urban hotspot in the world. And while they may be manifestations of a global phenomena, they are fiercely local and survive as bastions of creative potential.

We are craving a human connection, we are craving a story, we are craving something that is artfully made. That is what the best coffee bars do, they offer you as a person a connection to something real that has a traceable and transparent process that connects to the earth.

KEVIN BOHLIN, OWNER
SAINT FRANK, SAN FRANCISCO

Coffee Style can be found in cafés in London, Berlin, San Francisco, Tokyo or Melbourne, to cite but a few locations. The cafés are often within newly popular or up-and-coming neighbourhoods, and while the clients are a mixed bag, overall they tend to form a crowd one would generally call hep, in the early twentieth-century jazz-age sense of the word. After all, cafés have always been gathering spots for the creative community. Still, today cafés are a commonplace feature of urban life and point to a number of current developments.

Let's start our tour in California. Stylish cafés serving excellent coffee are all over San Francisco, and they have strong ties to the neighbourhoods they call home.

Kevin Bohlin's Saint Frank is in the Russian Hill neighbourhood. Sceptics doubted the area was ready for anything else than Peet's or Starbucks, and they both indeed have shops just down the road. Yet Saint Frank has proved the doubters otherwise. The café has become a local hangout. The interior is white and wood with ample space. The long bar is set low, about hip-high, as Bohlin wanted to encourage easy conversation and fluid service. His customers have meetings over coffee, write in notepads, read their tablets or type on mobile devices. They create and communicate. As a trained cultural anthropologist, Kevin believes "coffee has this creative power and potential in people's lives". In those of his clients but also his own. For example, the Saint Frank logo and font was custom-designed by a personal friend.

Back in the Old World, at Volcano Coffee Works, a London roastery, owner Olaf Wiig also speaks about the creative potential of coffee. Wiig used to document wars as a correspondent cameraman, but he finds his new job no less imaginative, though certainly less dangerous. He believes that shared interests, such as coffee, bring people together: "Coffee is just a drink, but there is a subtlety to it, the detail. It means that the people who get intrigued by it end up having other overlaps in their life and thus end up with these immensely creative spaces."

Cafés have indeed historically provided creative spaces for artistic movements. In the early twentieth century, for example, Dada artists met in coffee houses throughout Europe. In the United States, Italian immigrants made espresso a fixture in the 1950s. It then helped to fuel the literary movement led by such figures as Allen Ginsberg. For him, coffee was the one legal high. When the Beat poets later settled in Paris, they frequented the same haunts as Henry Miller and Jean Genet once did. For intellectuals like Simone de Beauvoir and Jean-Paul Sartre, the cafés of Paris were, quite literally, existential – places to meet and work.

While it is difficult to identify an equivalent avant-garde movement today, coffee houses

still function as both living room and workplace for artists and creatives alike. Modern-day digital nomads no longer sit behind a desk in an office but freely move from coffee shop to coffee shop with laptop in tow. And it is for them that The Archery in San Francisco was created. Though technically a shared office space, the aesthetic mimics that of a coffee house. Founder Randall Stowell recalls the community-building exercise of setting up another of his ventures, the café Front: "Once Front was opened, it became a meeting space for a lot of people. And they cared about the experience. They did not just want to grab a coffee and go. People that are driven by experiences, they will always try to find something different or unique." But with The Archery he is responding to the trend of a "whole mobile workforce changing how they work". While they want the café experience, they want it separate from the office.

Ralf Rüller from The Barn, a roastery and café in Berlin, sees the same logic. His spacious locale has a designated "media corner" but otherwise bans laptops from the rest of the space and particularly from the window tables. Rüller hopes that "people will turn to each other and away from their screens".

A situation in which a person is present but otherwise occupied with a cell phone has been labelled by psychologist Kenneth Gergen "absent presence": "One is physically present, but is absorbed by a technologically mediated world of elsewhere." It is the opposite of what Gergen calls "full presence", which is expressed in "face-to-face relationships". The latter space is what coffee people such as Stowell, Rüller and their customers are attempting to reclaim.

Full presence is also localization. Take California's Ritual Coffee Roasters, for instance, which injected new life into Bay Area's coffee scene back in 2005. Ritual played a role in the revitalization and popularity of San Francisco's Mission District and has gone on to open in five additional locations. Their products are often inspired by the "instant city" itself, such as its Windy Picnic blend, a seasonal espresso named in homage to Mission Dolores Park during autumn.

Ritual owner Eileen Rinaldi explains that "building a good café is about creating an ecology in which community can grow and thrive". It can be a "collaborative artwork" but also the "expressions of somebody's ego". For her, it is a collective effort; she believes that communities can be teased out in places where no café has gone before, and that the people will follow. Or simply leave their houses, as Rinaldi shares an anecdote about two artists that lived next to each other for ten years but only met for the first time at Ritual. There is a Ritual outpost located in a nursery in an industrial section of San Francisco, the café nestled amongst the cultivated jungle, where they serve an exclusive, signature beverage, the Cherry Bomb. Invented by the barista there, the cold-brew coffee and Fever Tree tonic water topped with a maraschino cherry is an ideal concoction to sip on whilst surrounded by the garden centre's succulents, cacti and palm trees.

Signature drinks are common for the independent cafés that epitomize the coffee lifestyle. Whether featuring cold-brewed coffee or latte sprinkled with lavender, these inventions point to another creative aspect of these modern cafés – the makers. Their experiments with branding, signature drinks or latte art – and the very presentation of coffee that looks as good as it tastes – can definitely get one's creative juices flowing.

49

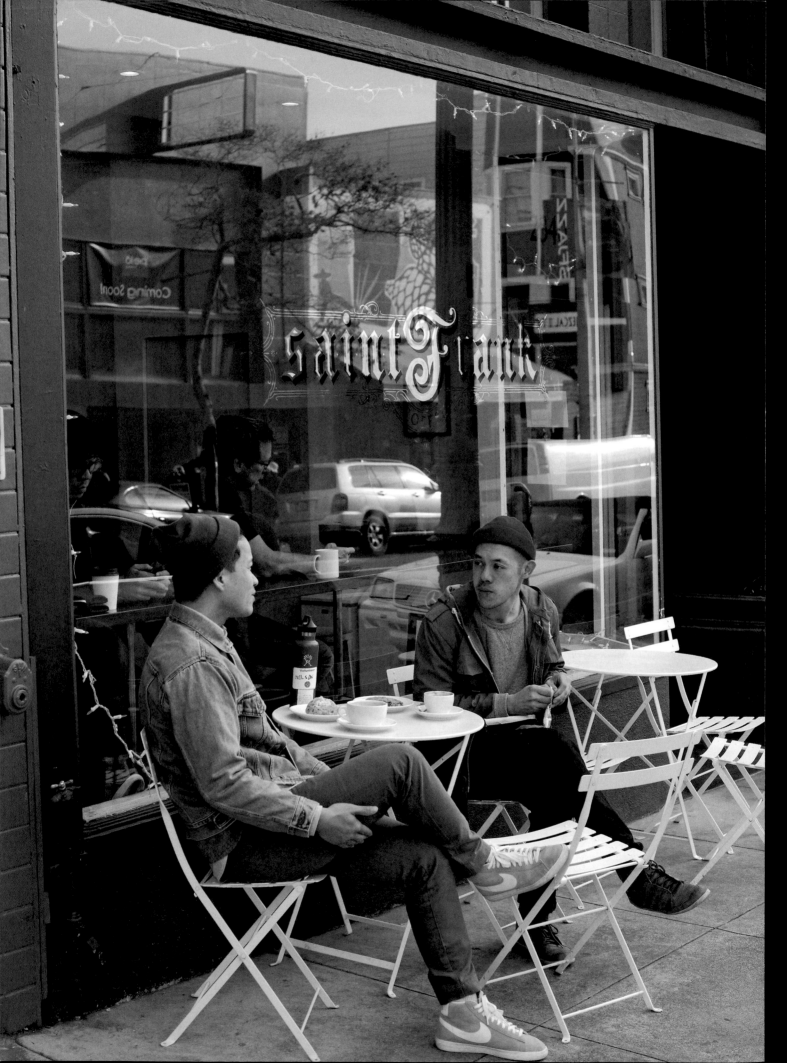

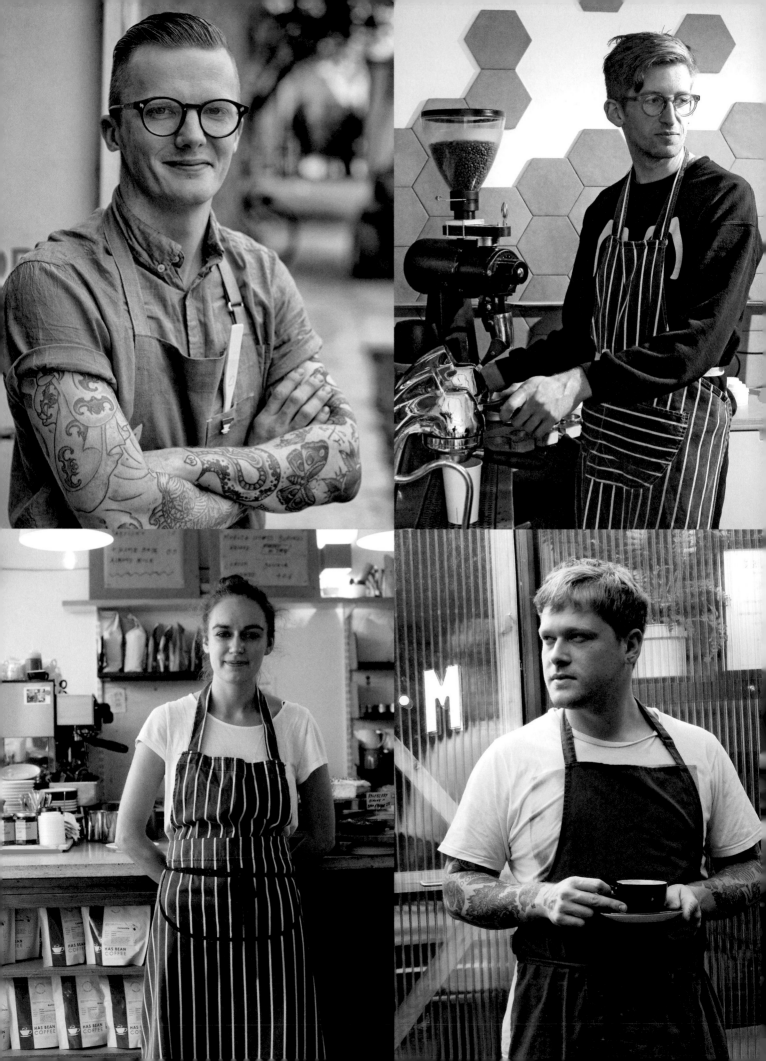

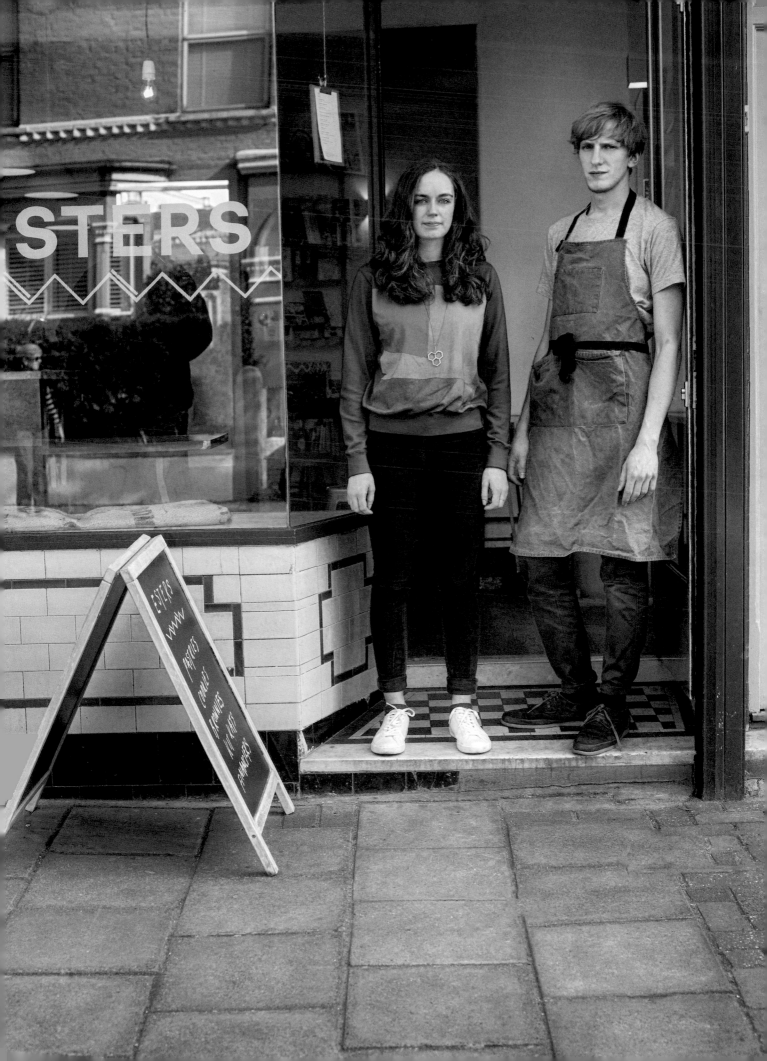

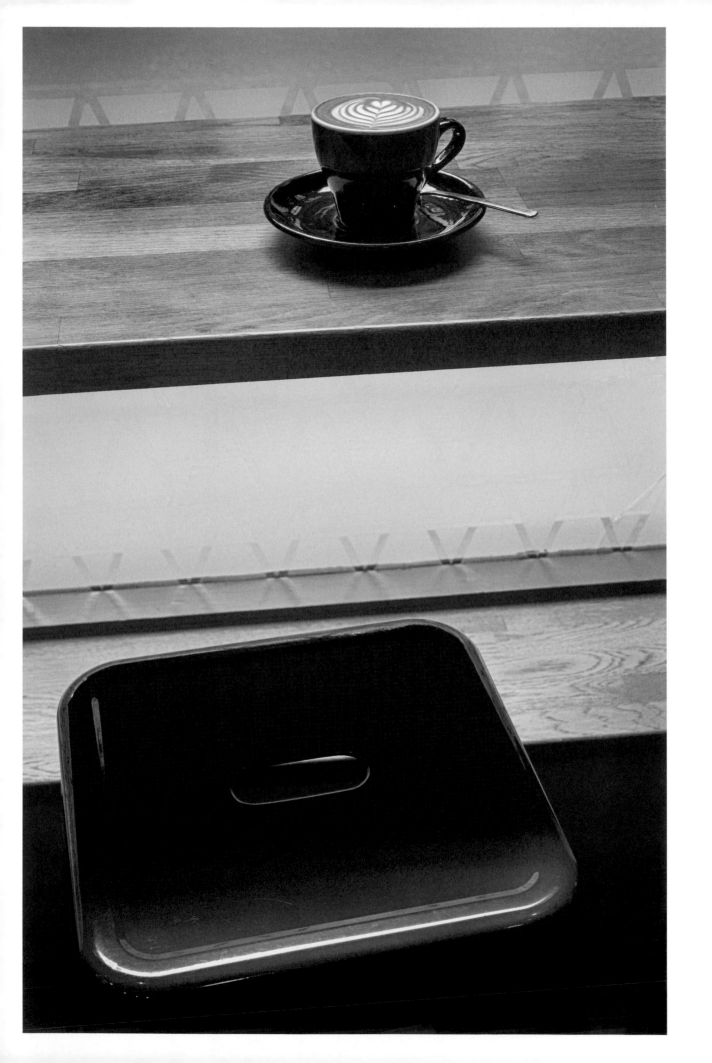

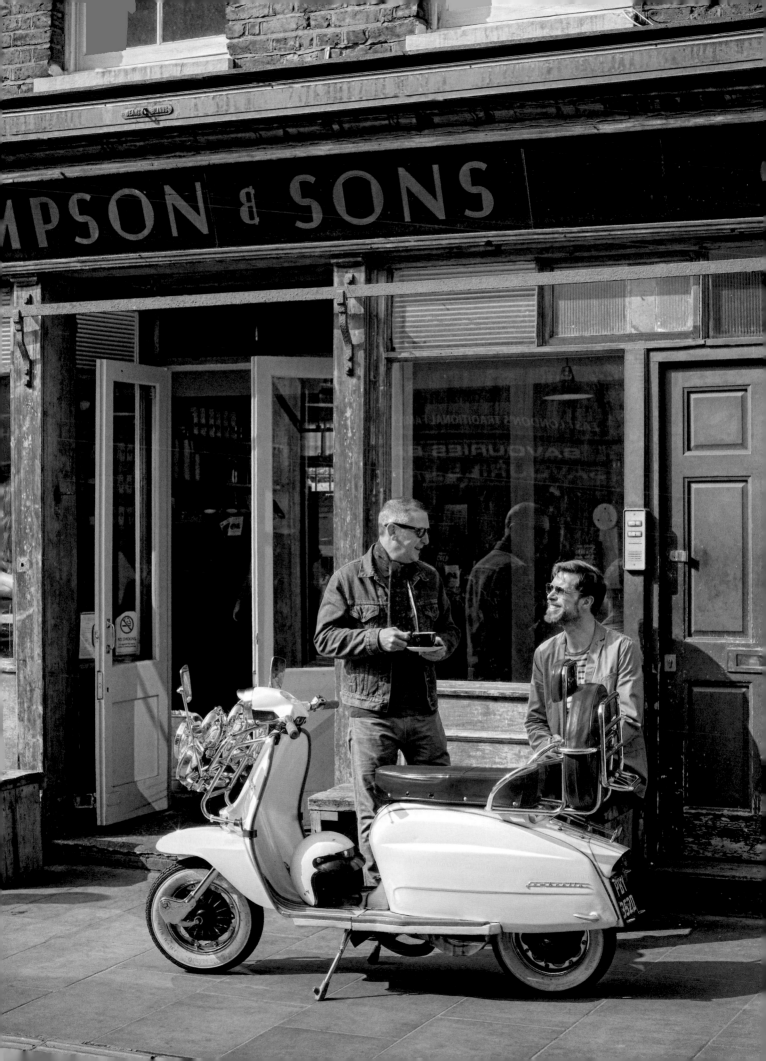

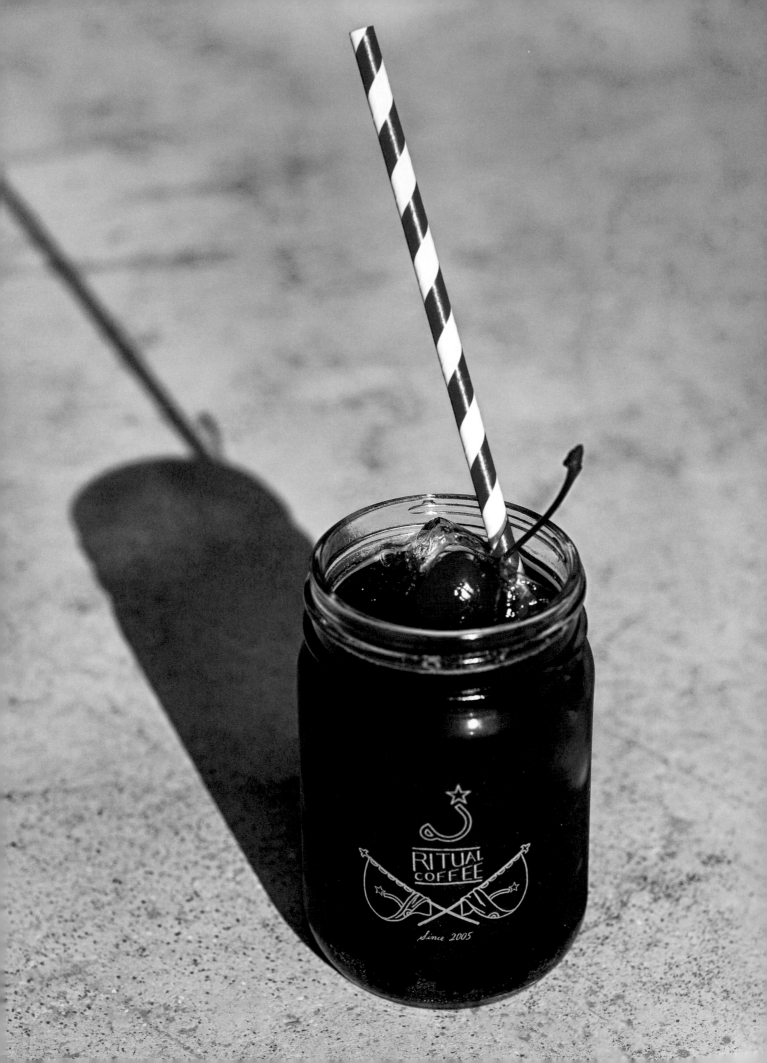

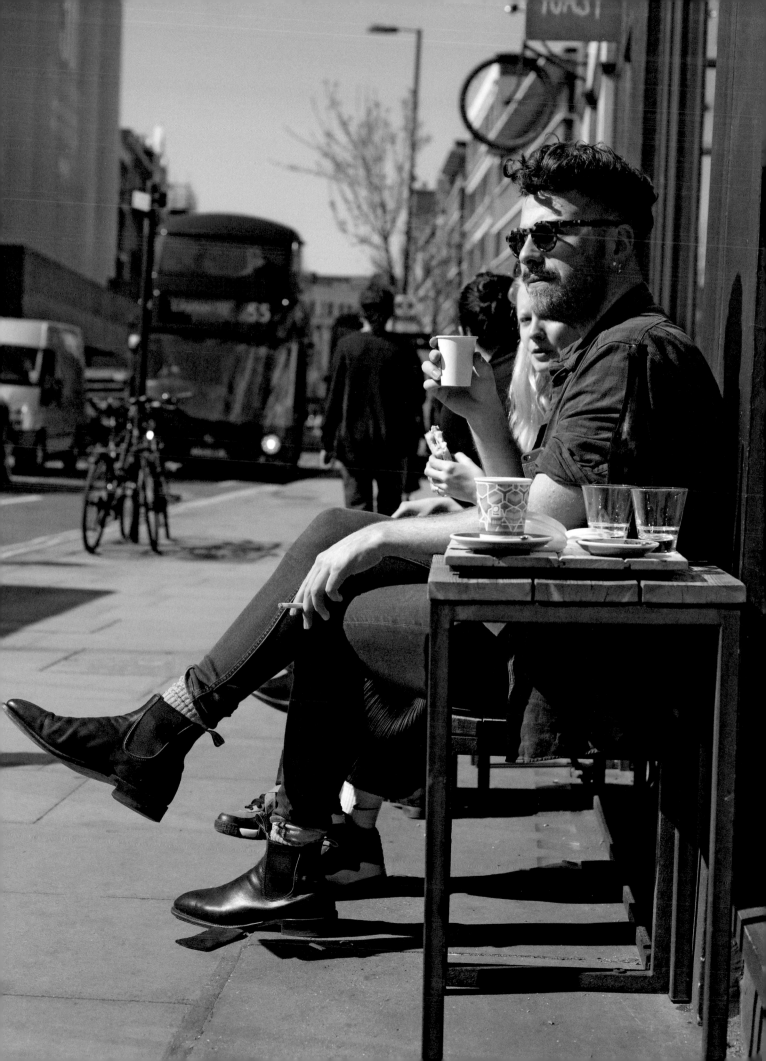

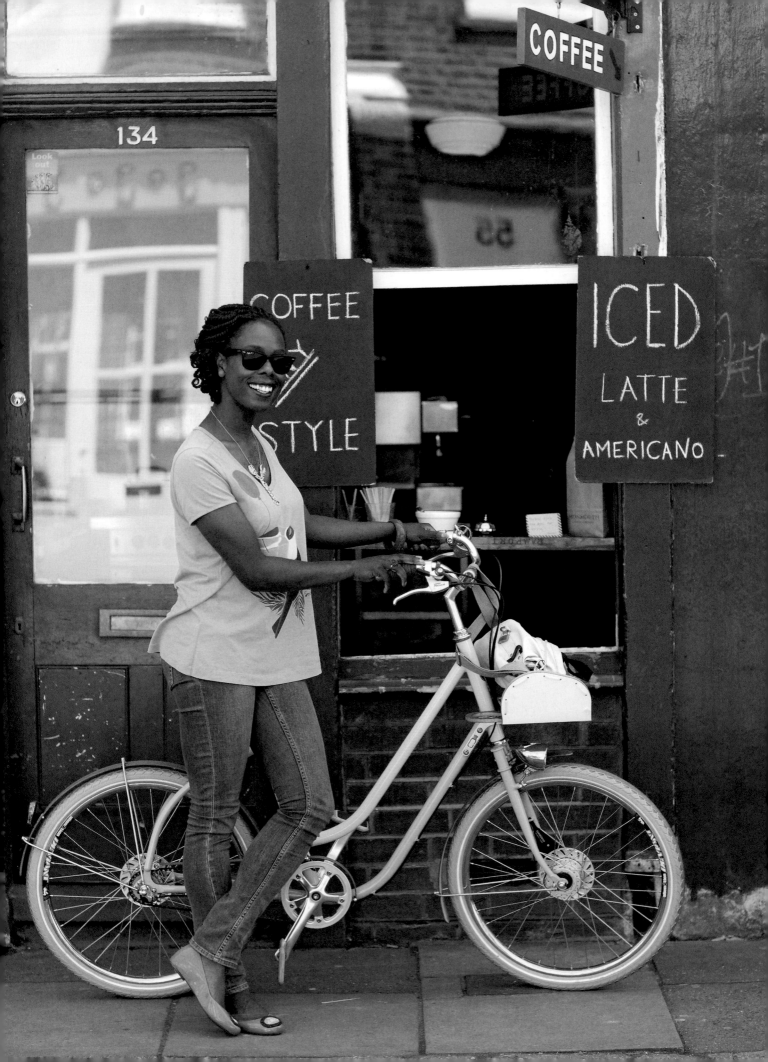

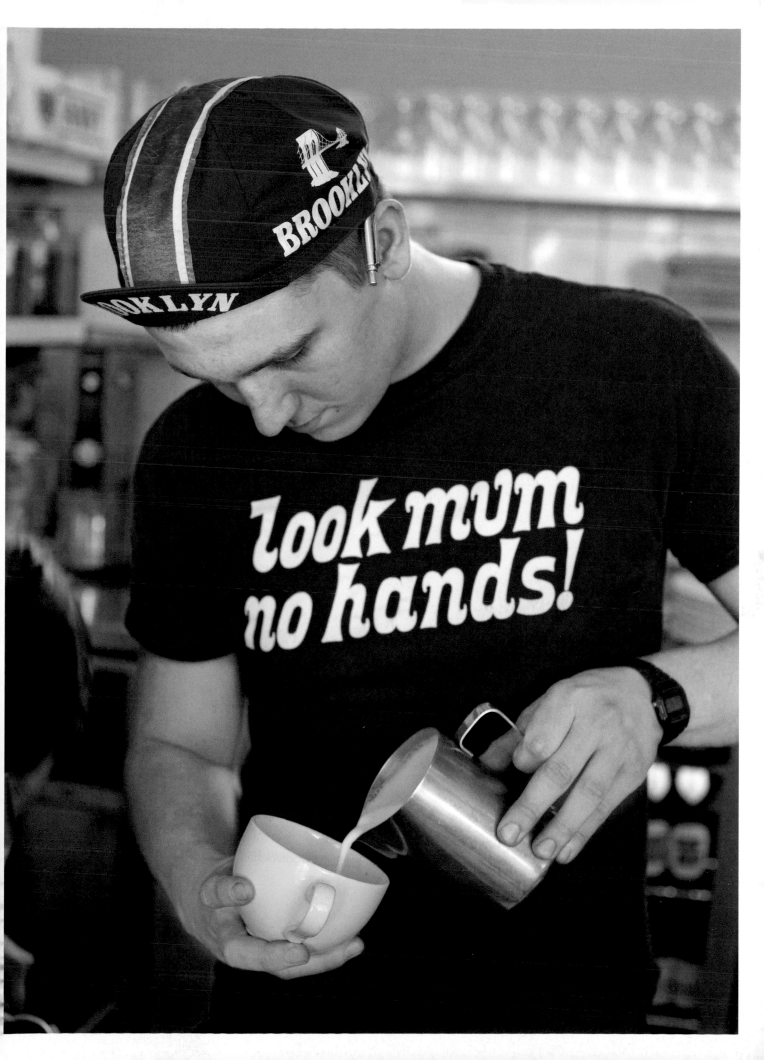

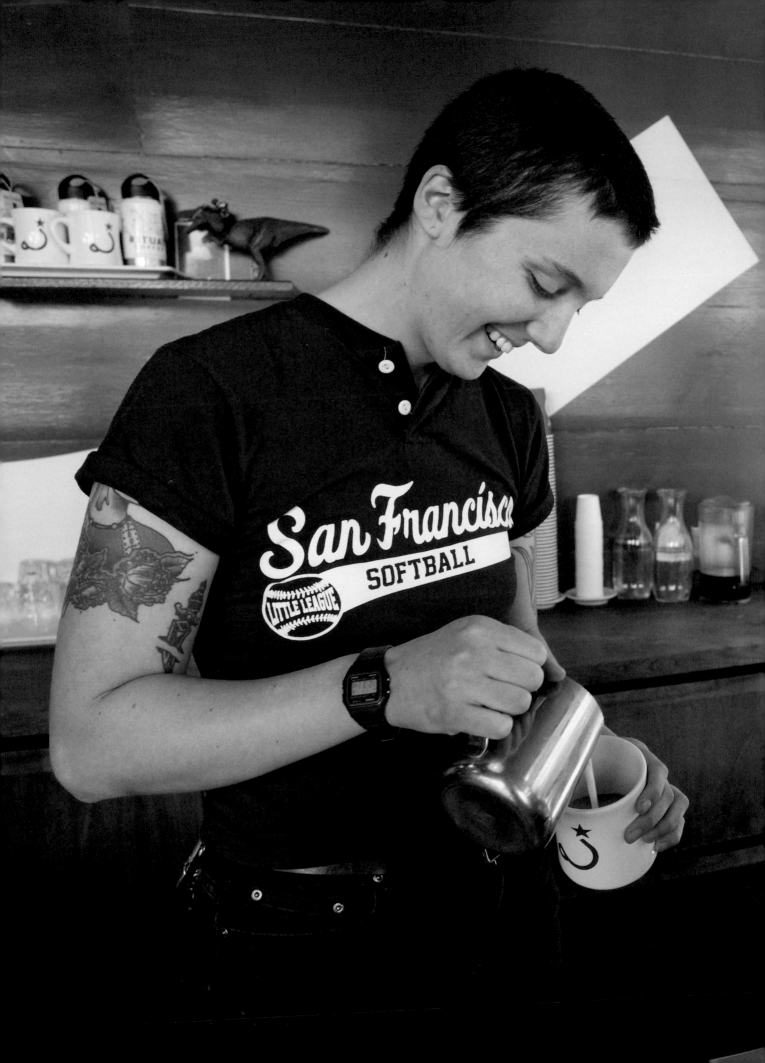

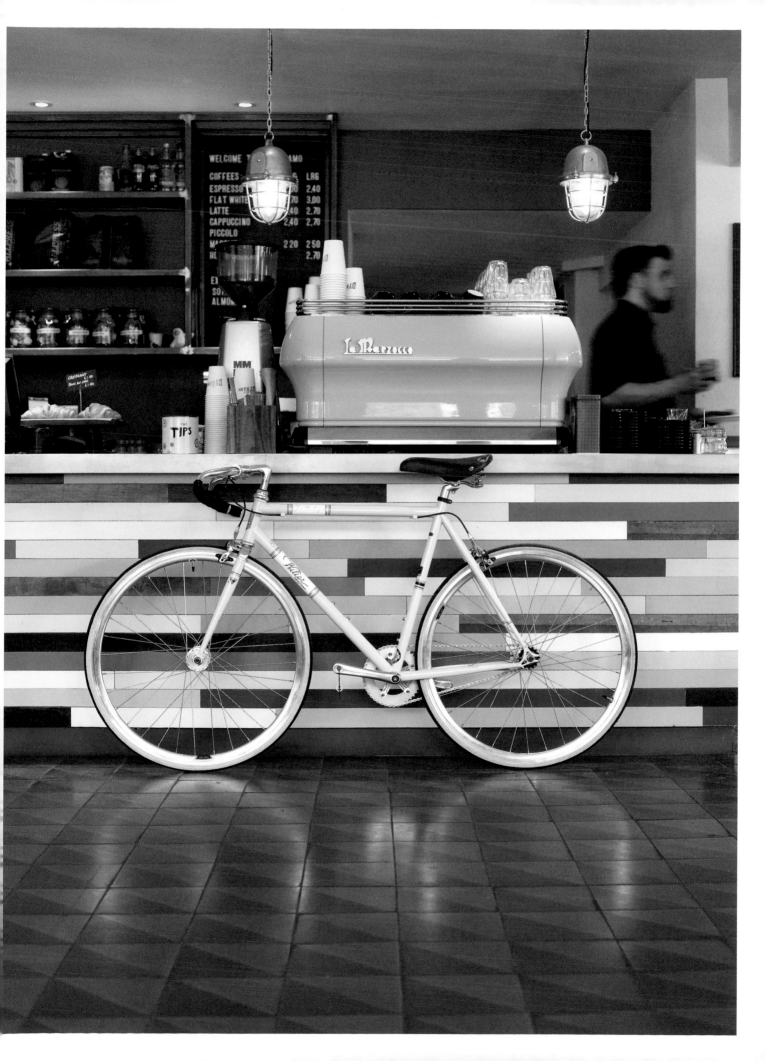

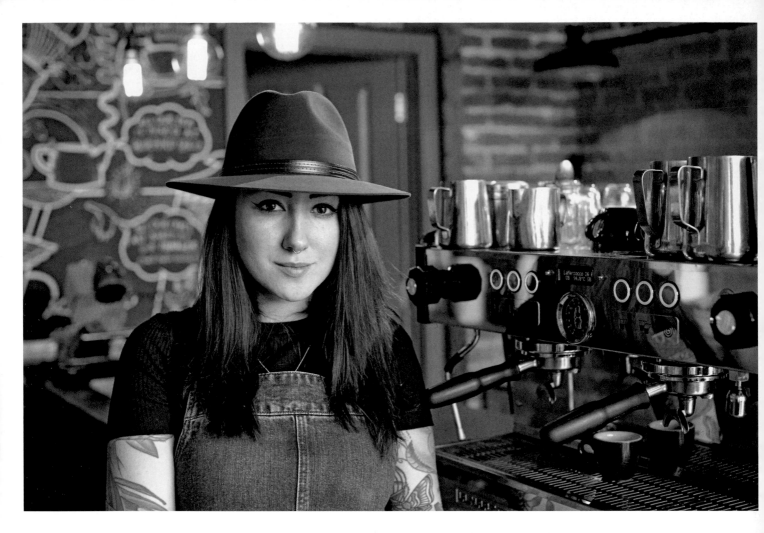

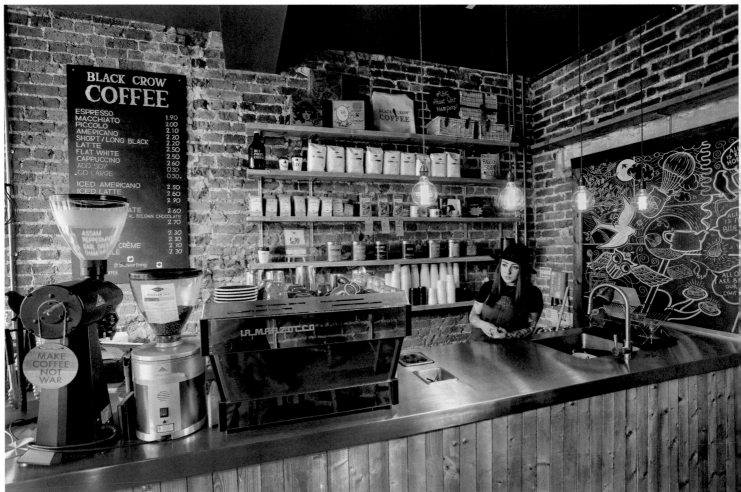

BLACK CROW
COFFEE

ESPRESSO	1.90
MACCHIATO	2.00
PICCOLO	2.00
AMERICANO	2.10
SHORT / LONG BLACK	2.20
LATTE	2.20
FLAT WHITE	2.50
CAPPUCCINO	2.50
ADD SOY	2.60
GO LARGE	0.30
	0.30
ICED AMERICANO	2.50
ICED LATTE	2.60
	2.90
ATE	2.60
REAL BELGIAN CHOCOLATE	
	2.70
ASSAM	2.30
PEPPERMINT	2.30
EARL GREY CRÈME	2.30
CHAMOMILE	2.30

MAKE
COFFEE
NOT
WAR

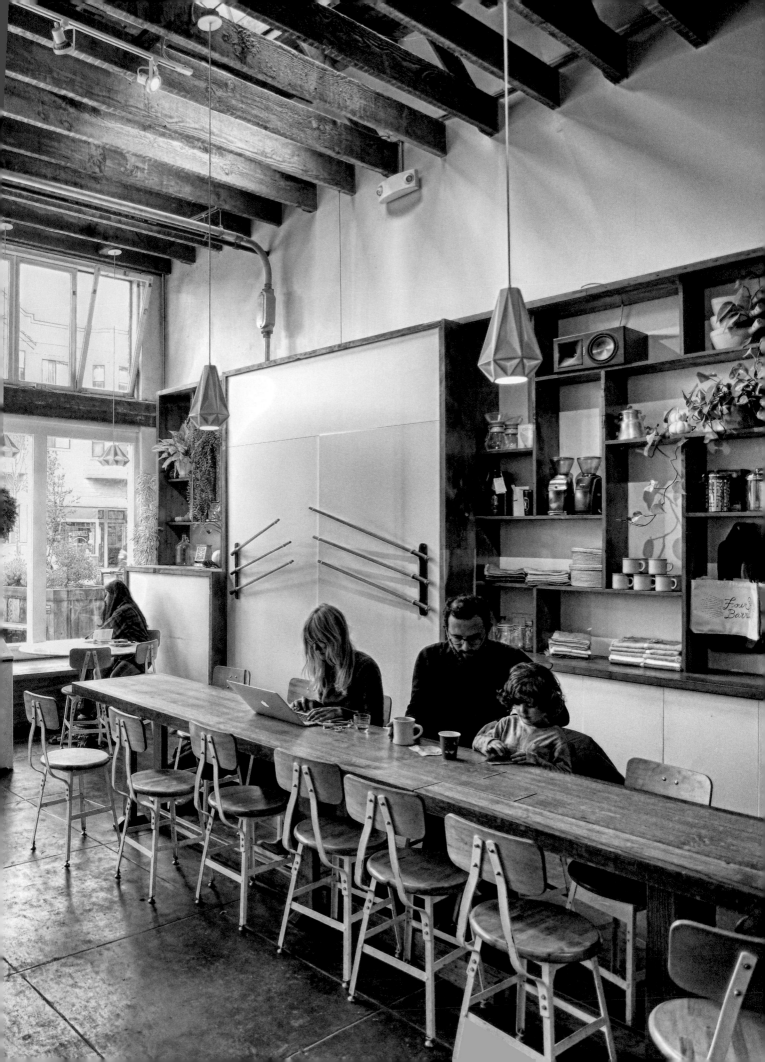

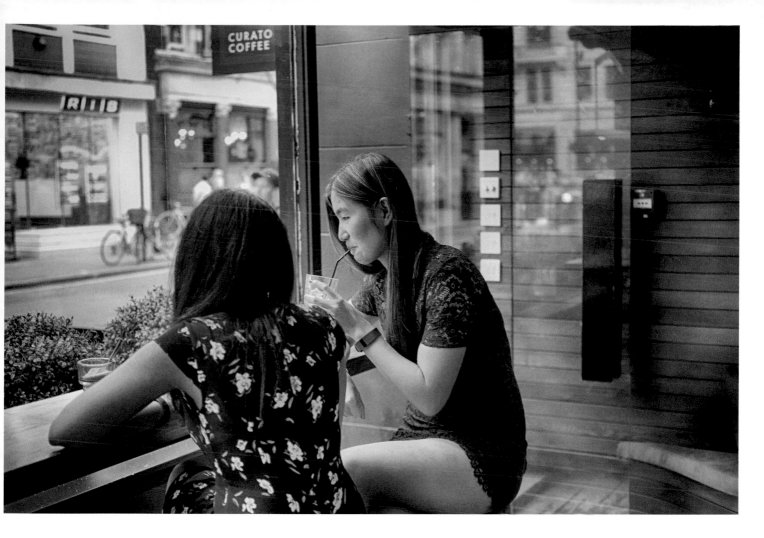

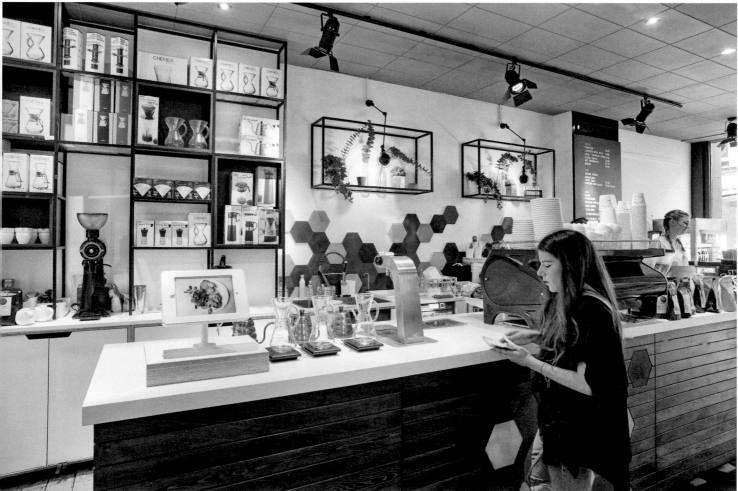

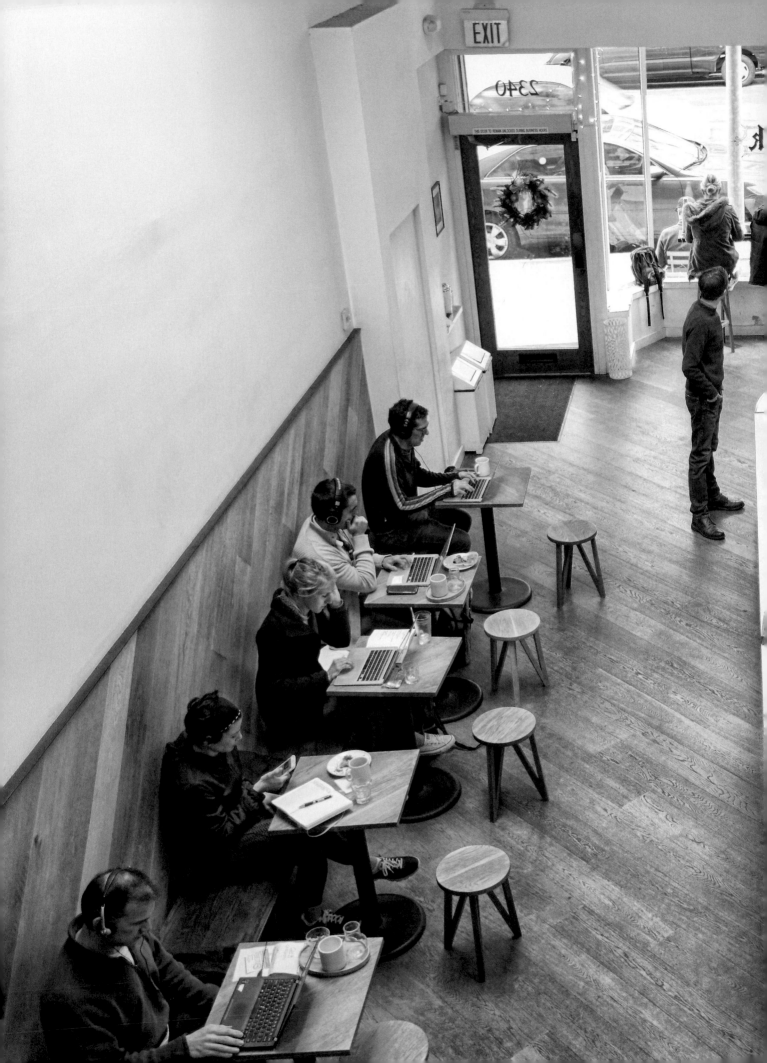

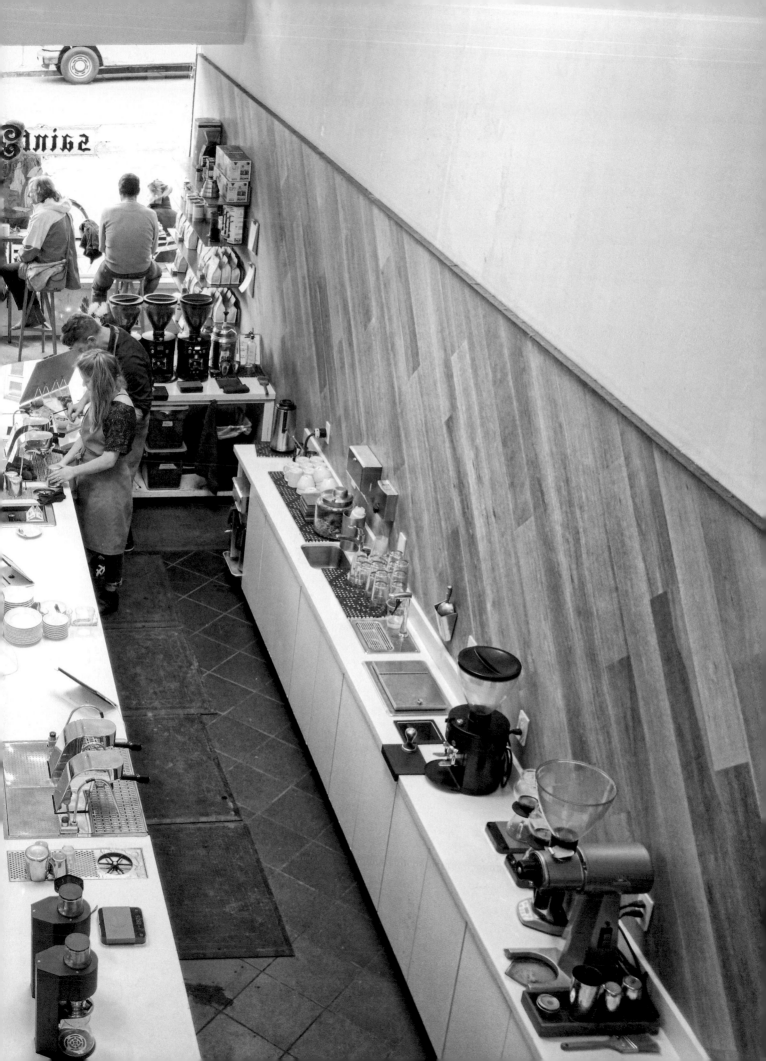

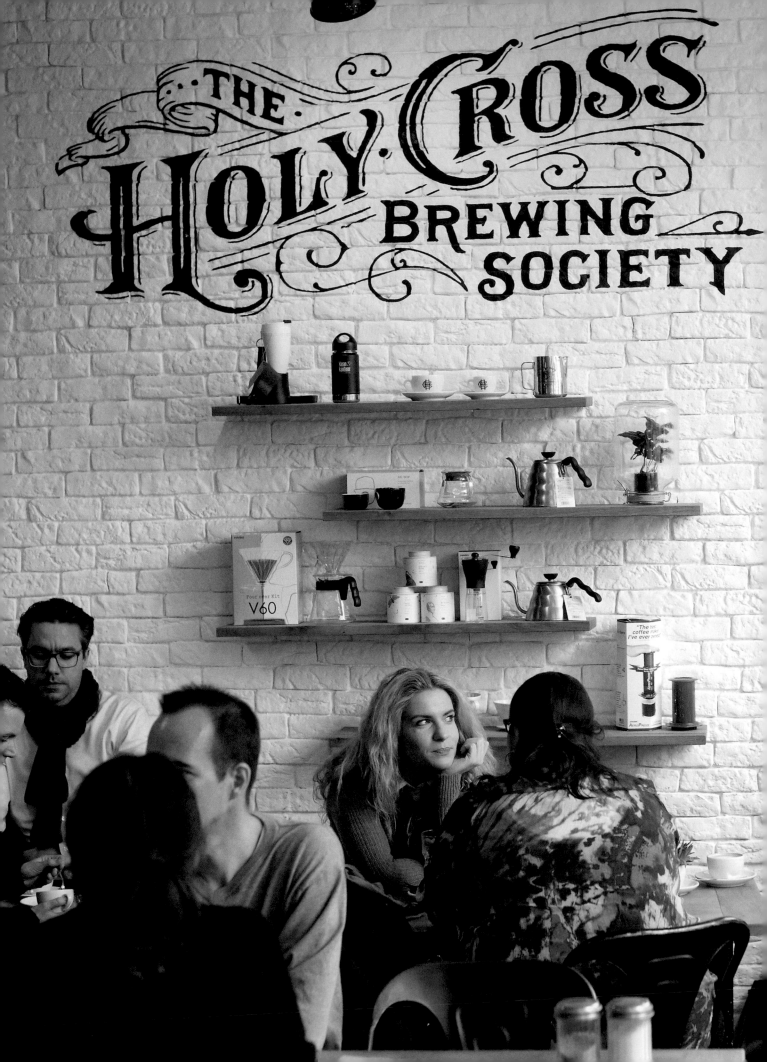

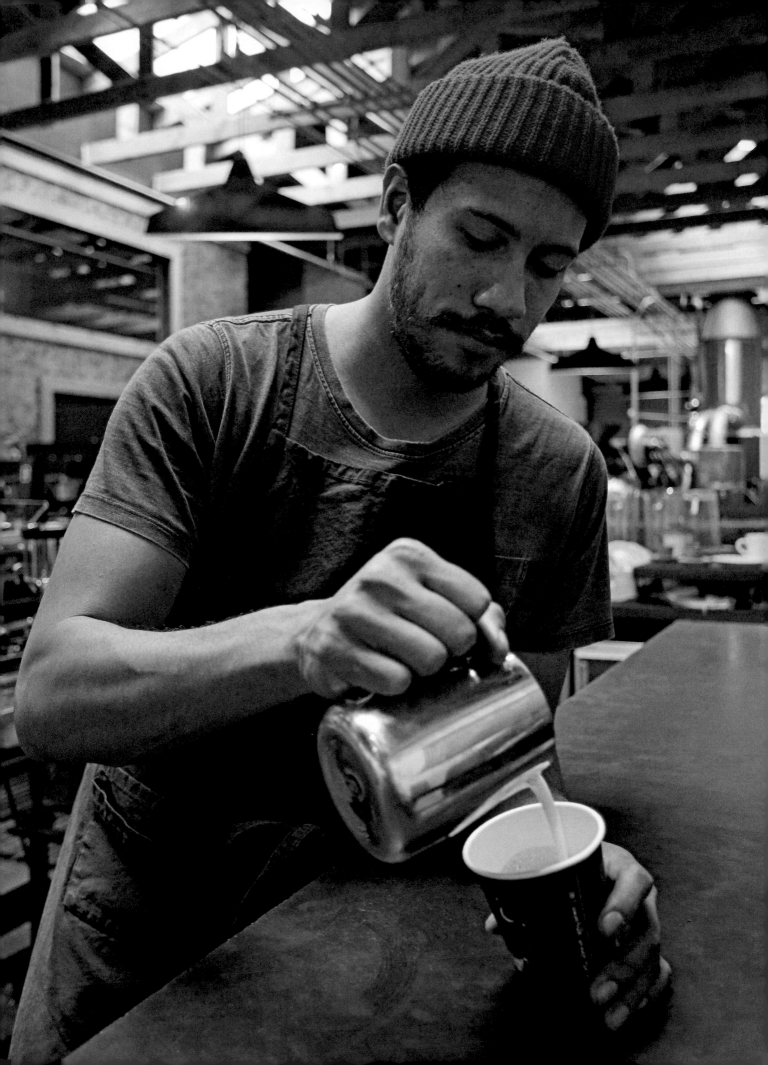

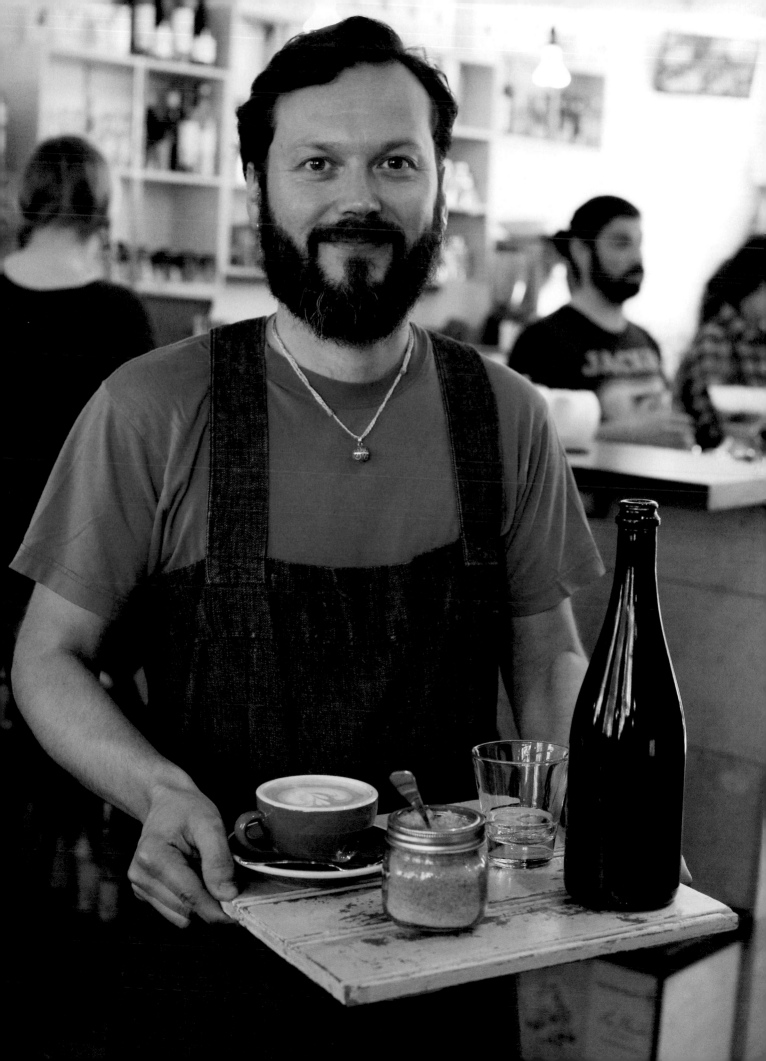

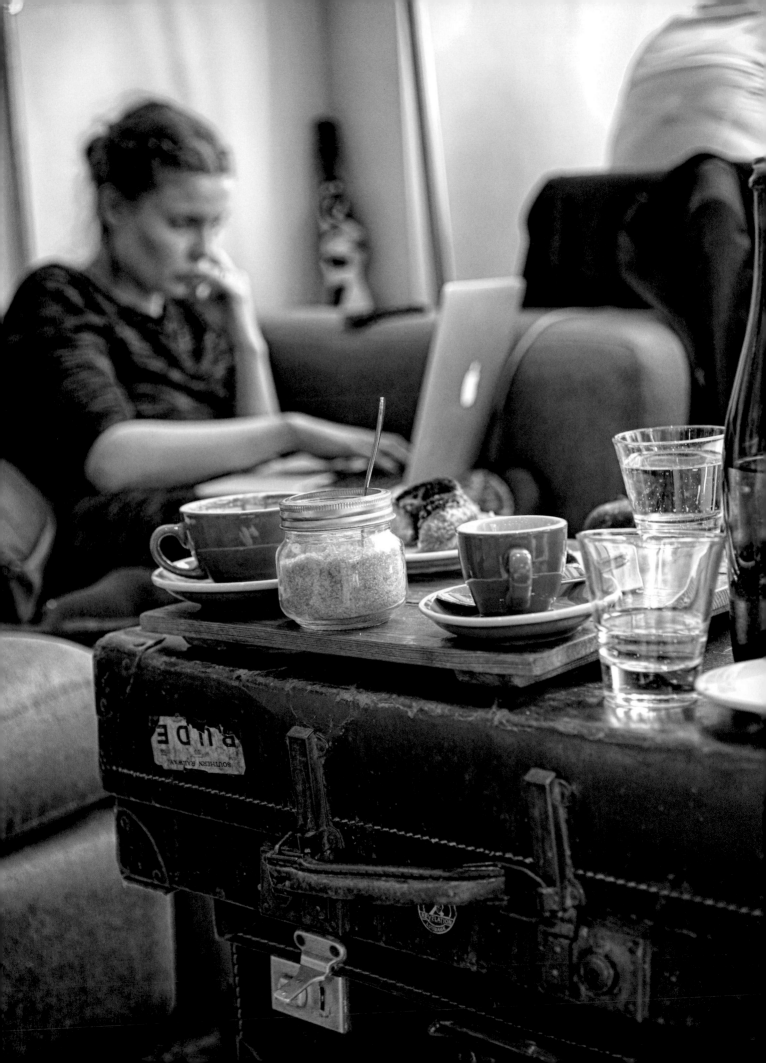

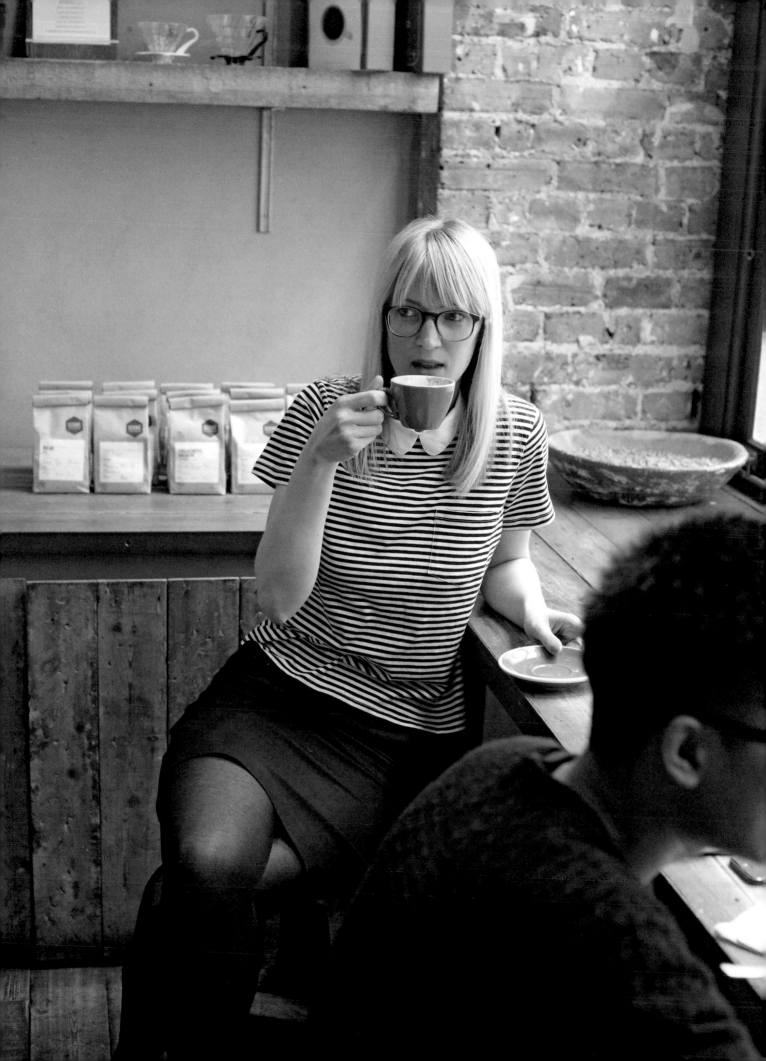

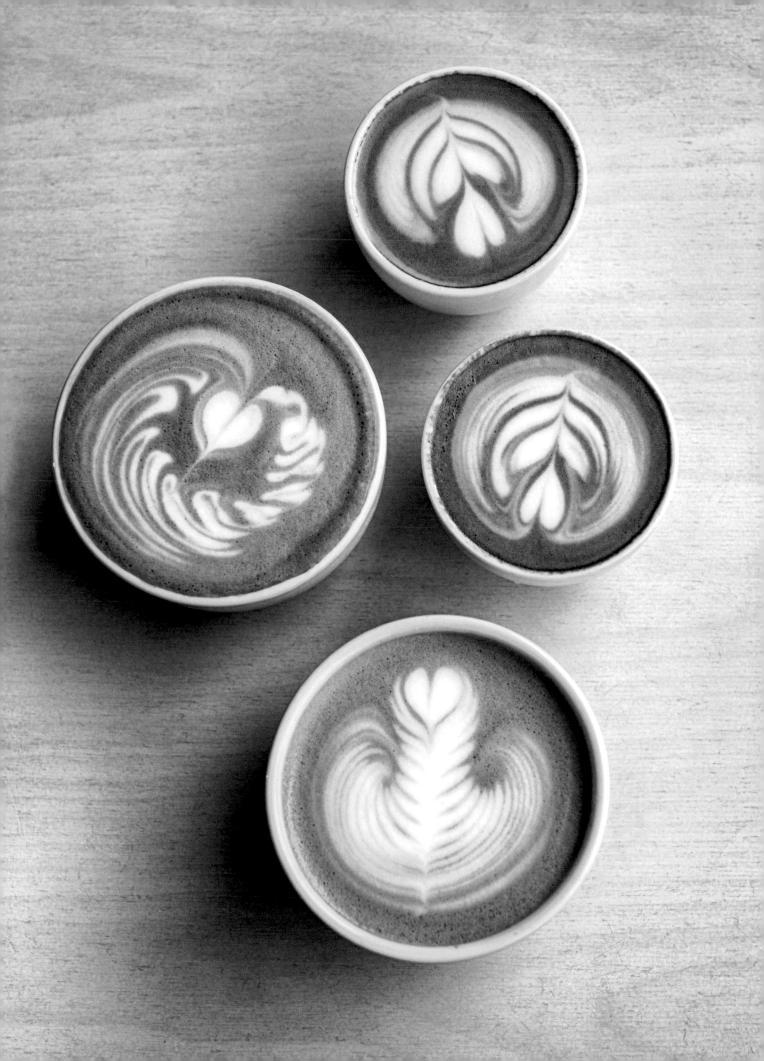

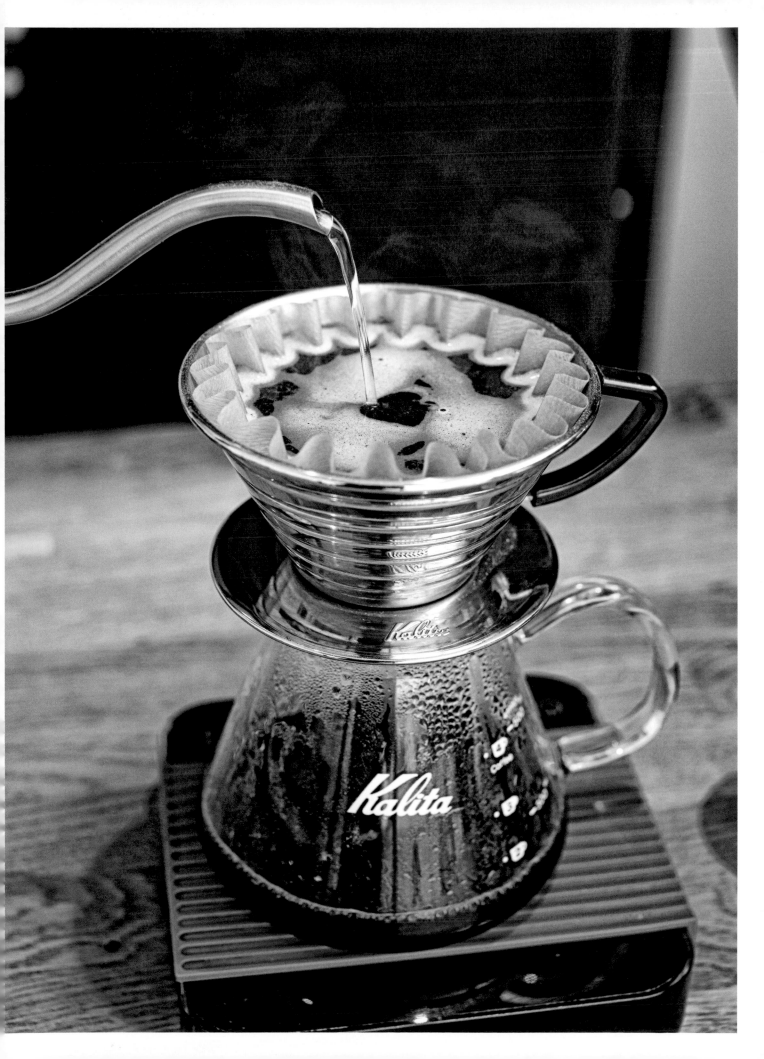

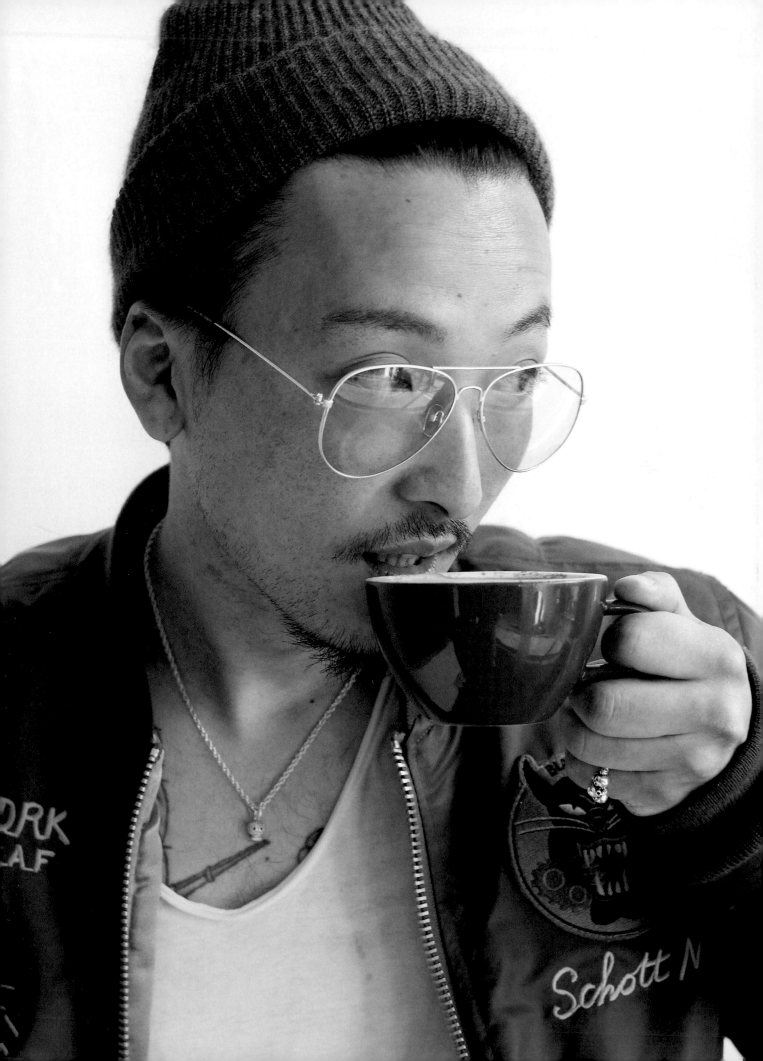

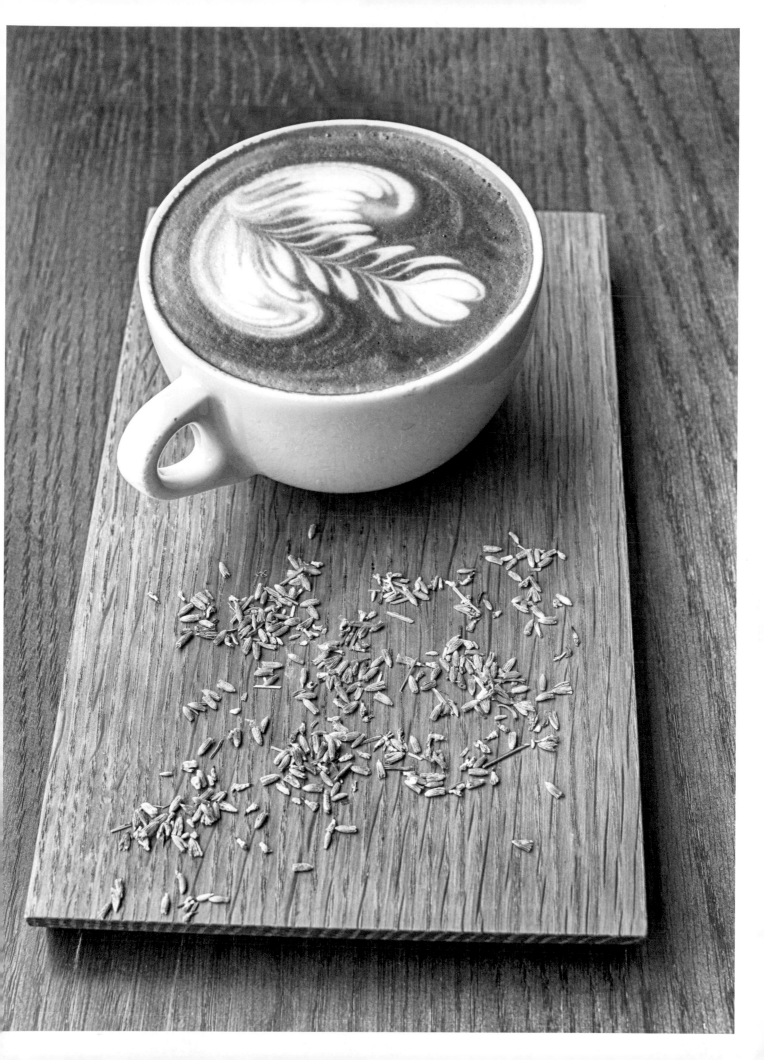

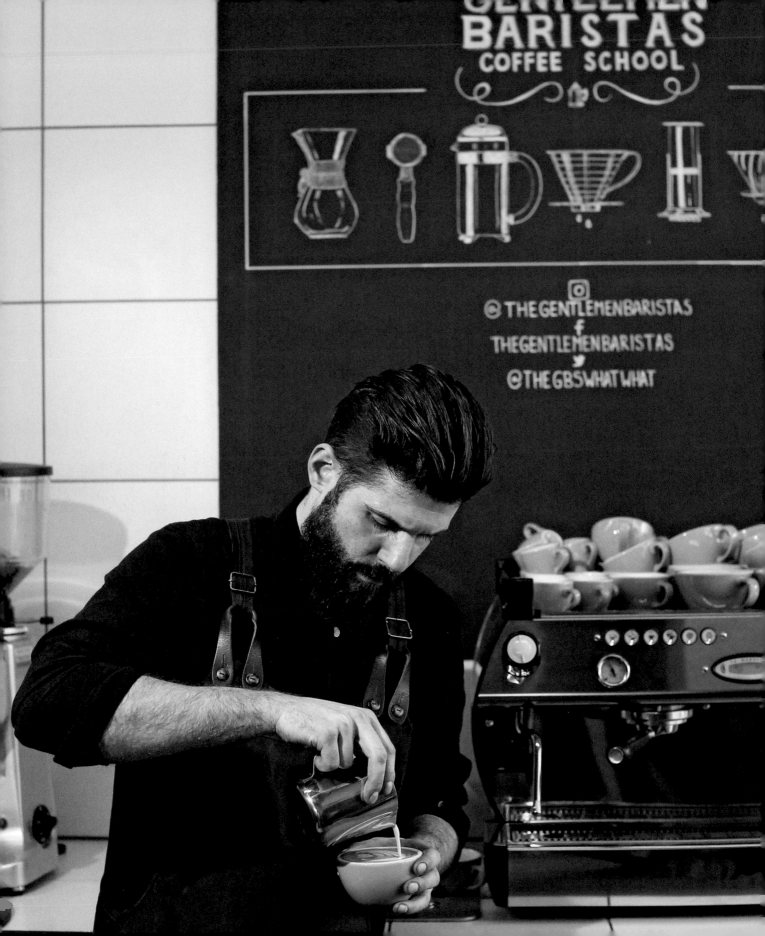

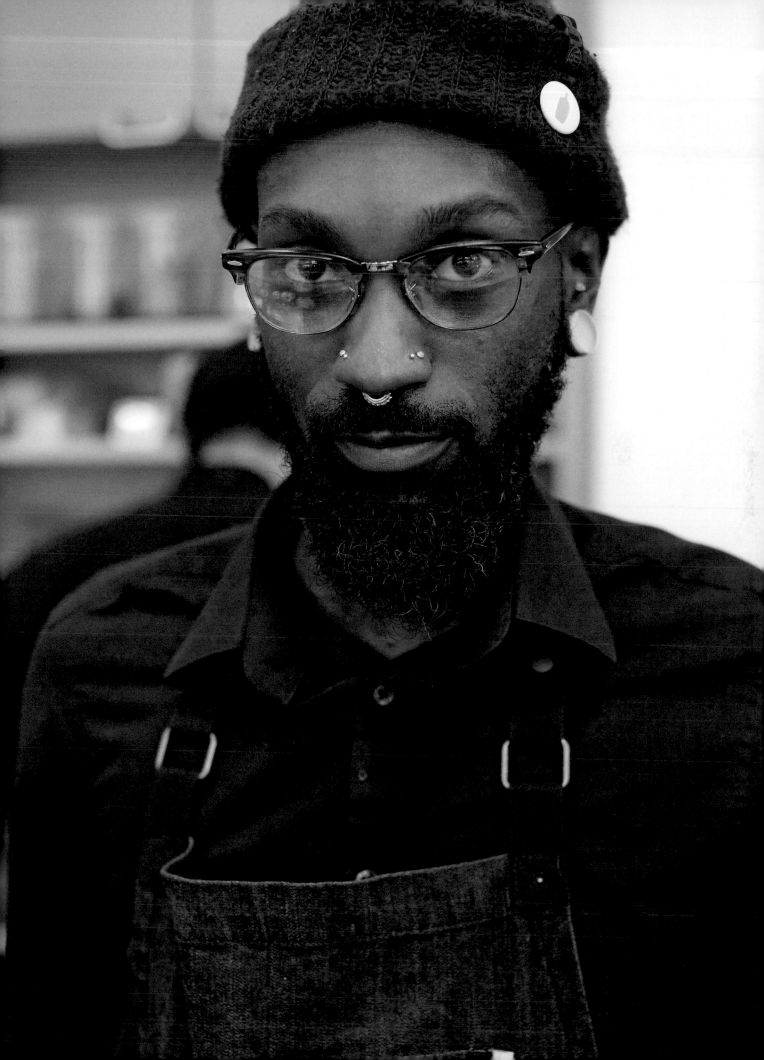

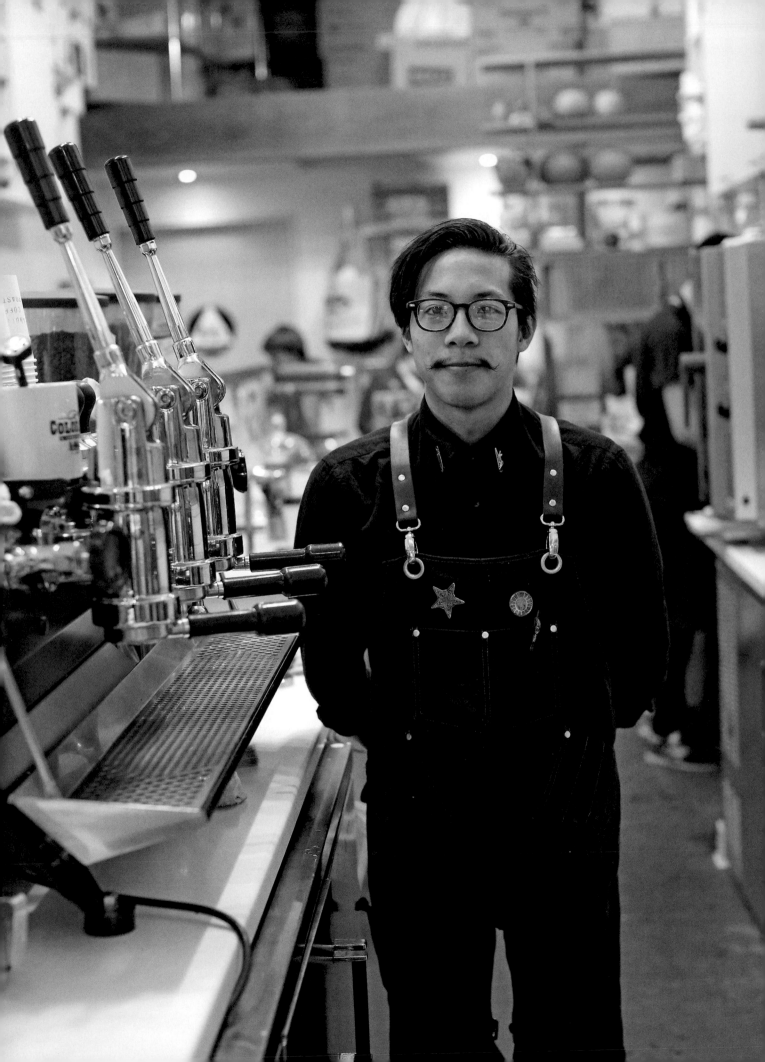

MAKER'S PRIDE

HUMANS AND MACHINES

An espresso may be small, but it is potent, and because it is made with a machine operating under high pressure it is nothing if not complicated.

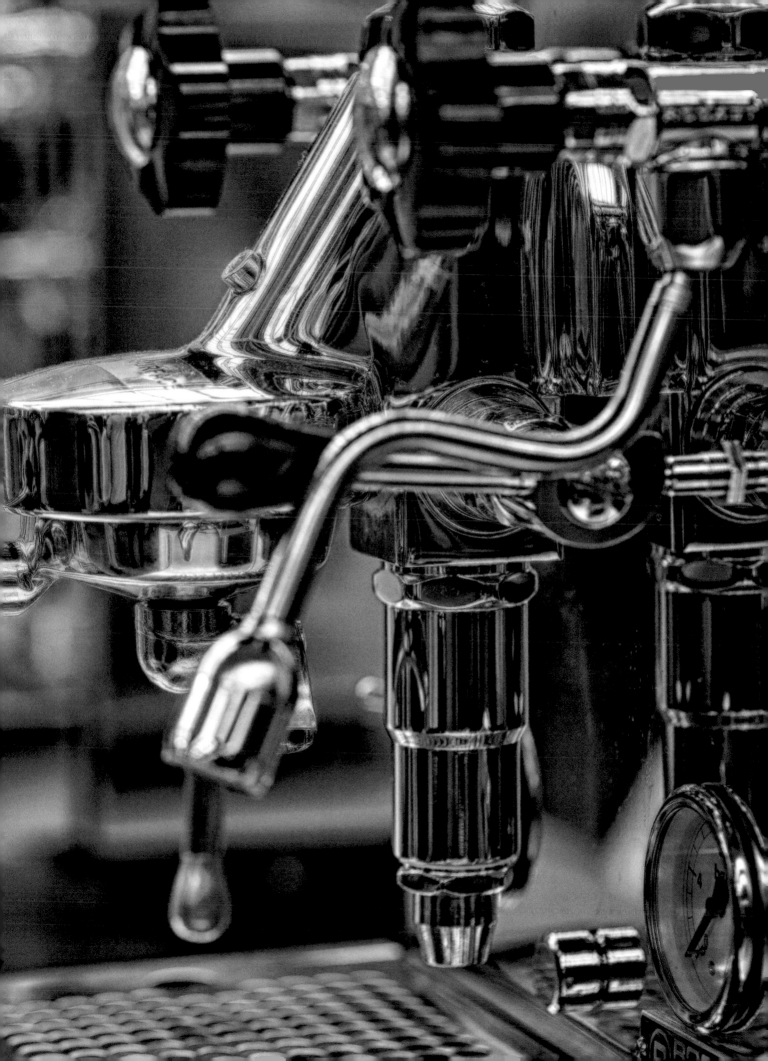

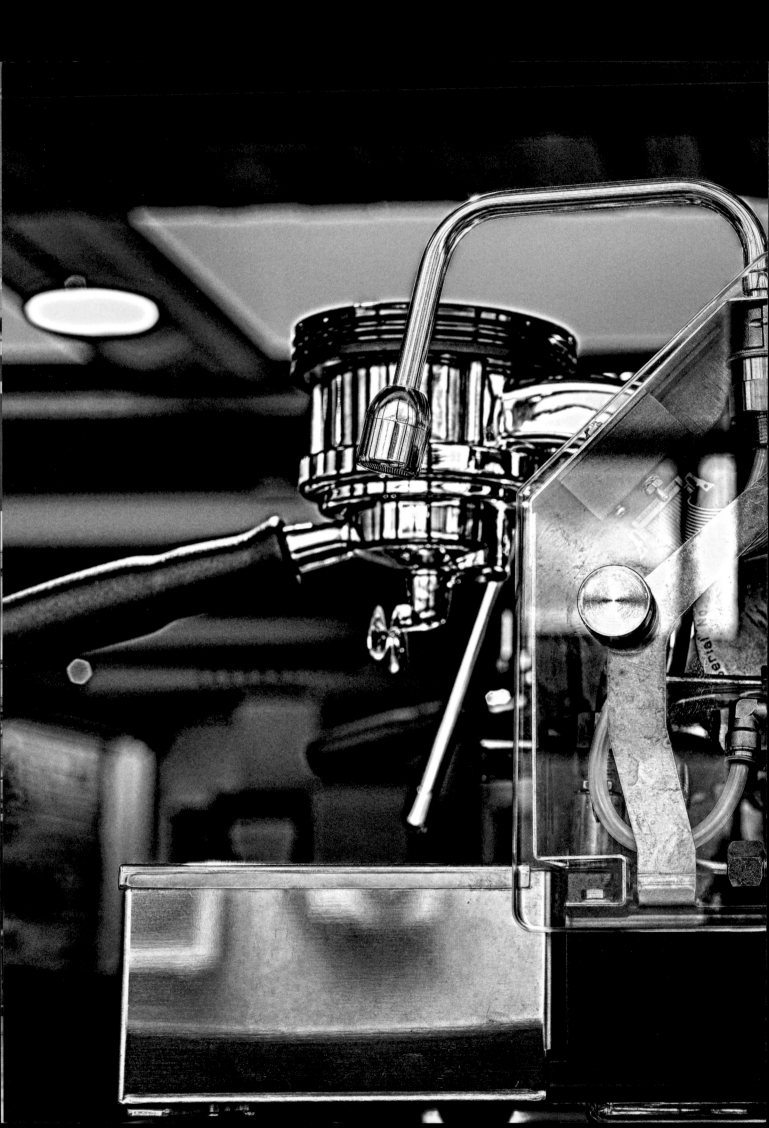

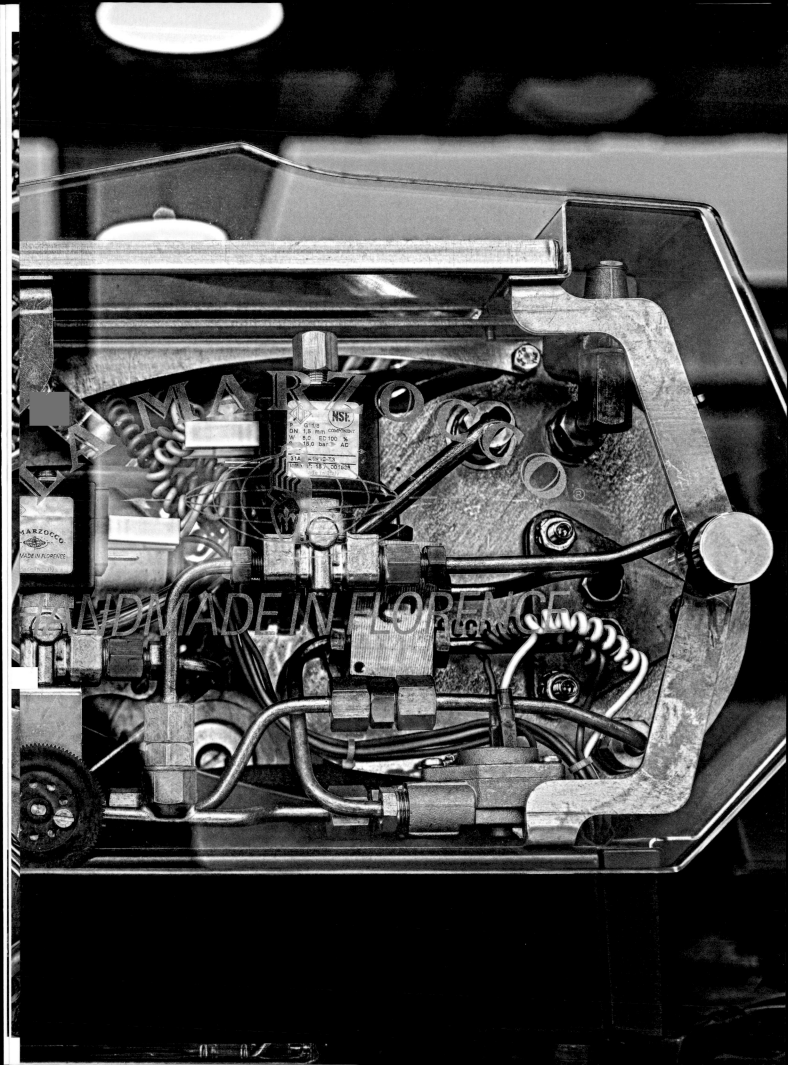

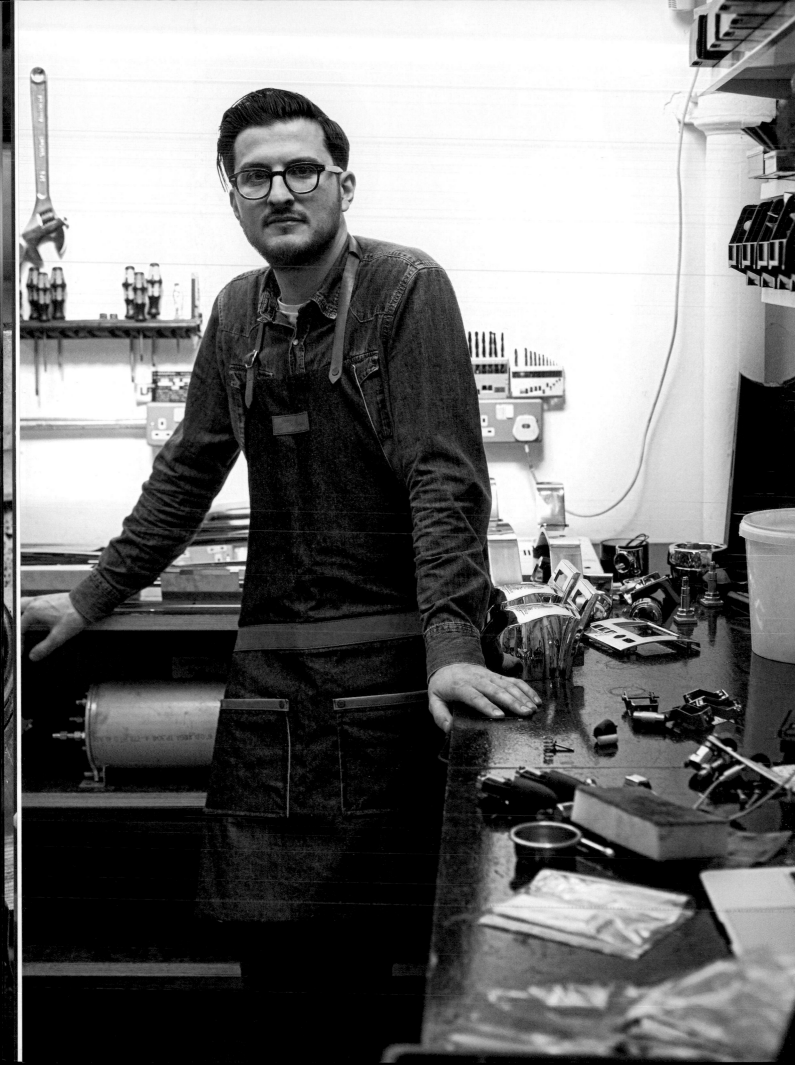

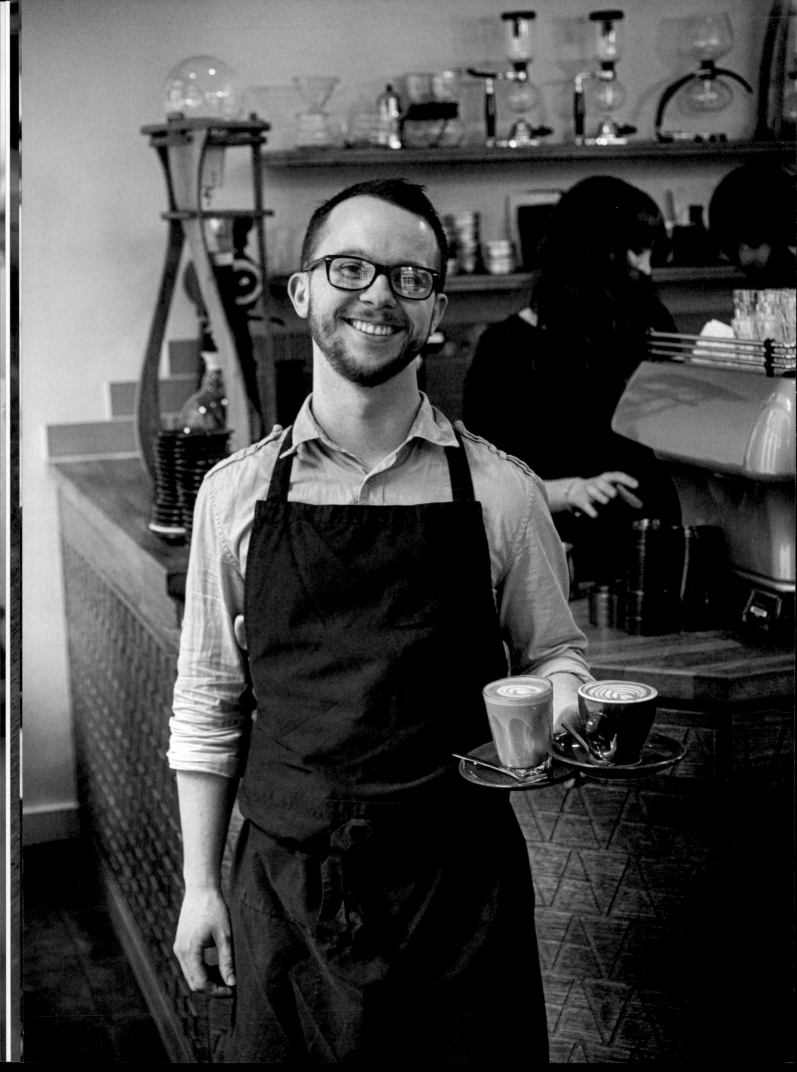

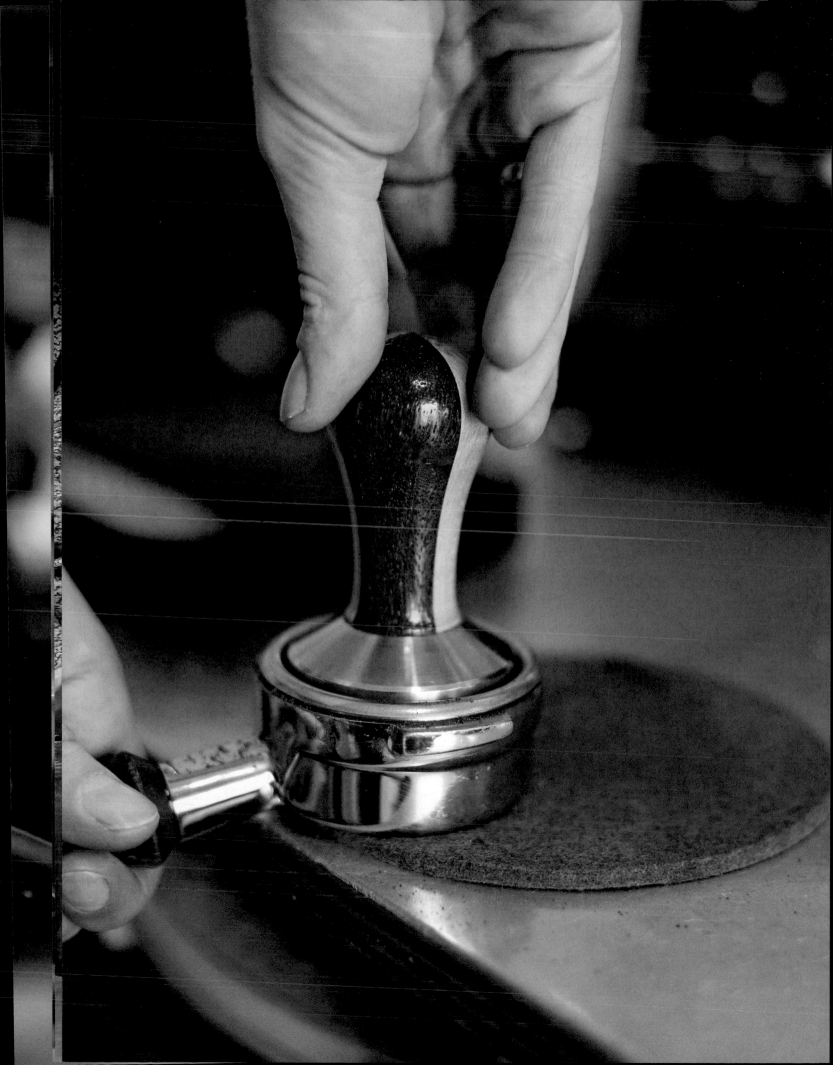

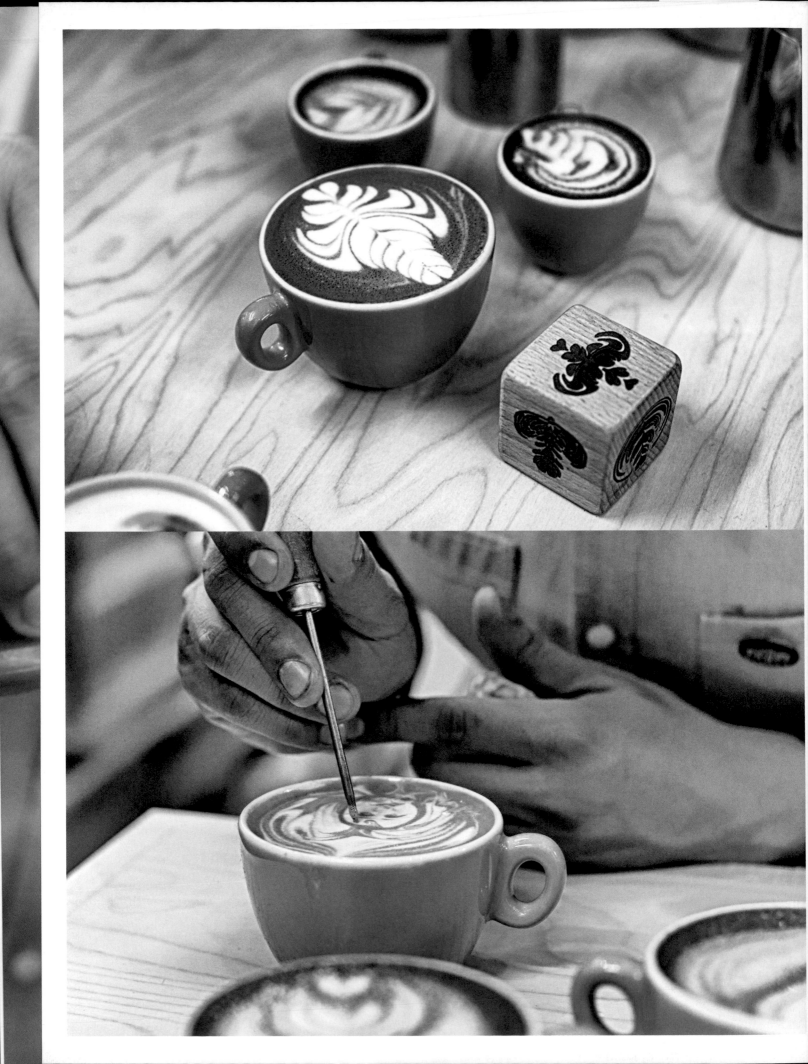

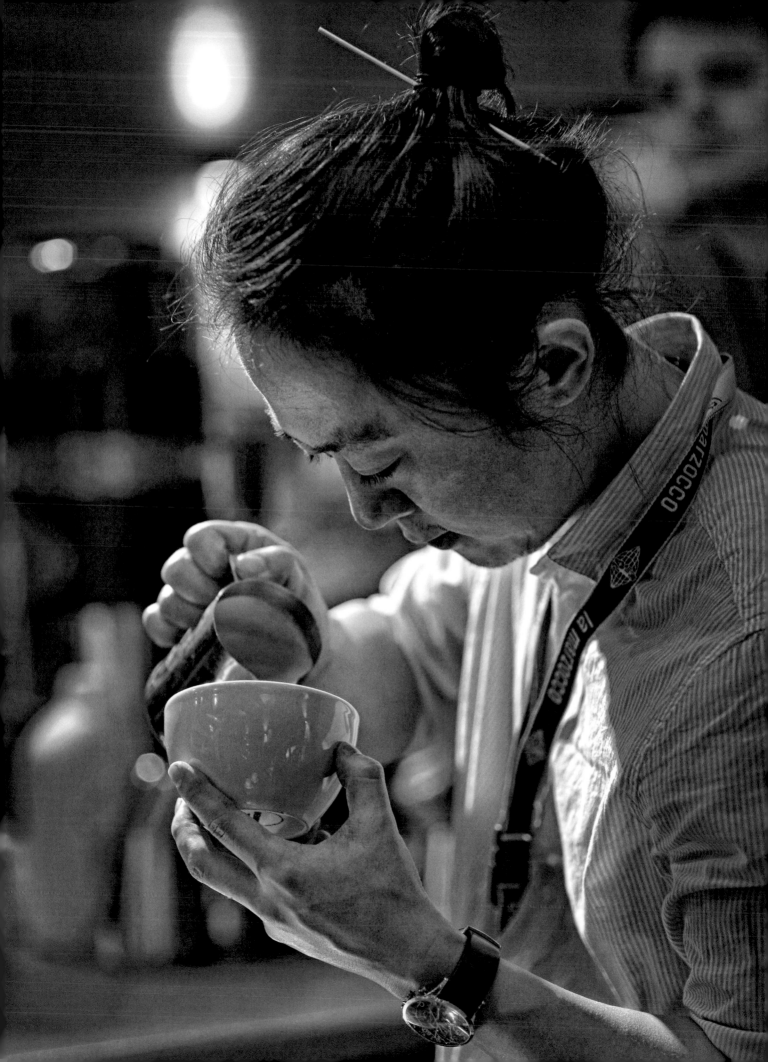

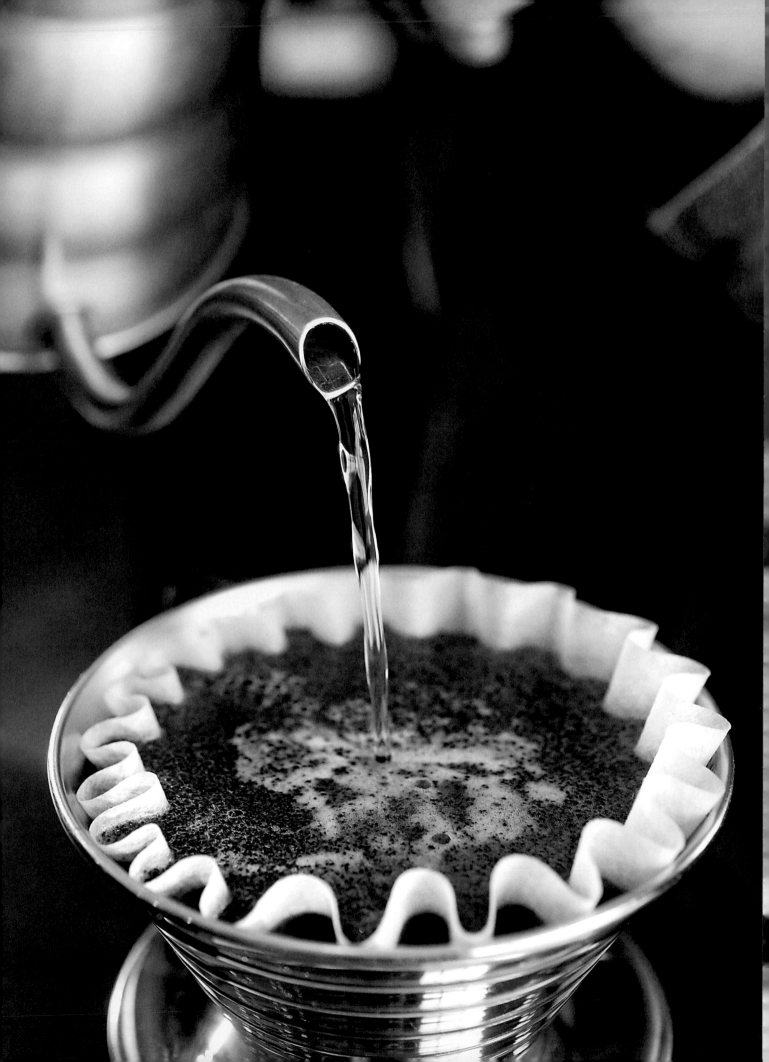

CATCHING FLAVOUR

SLOWLY DOES IT

What type of coffee maker do you use at home? A moka pot (macchinetta), a French press, an electric drip filter machine, perhaps even an AeroPress? Whatever it may be, you can be certain that there is equipment out there even more advanced, equipment that makes for quite a show.

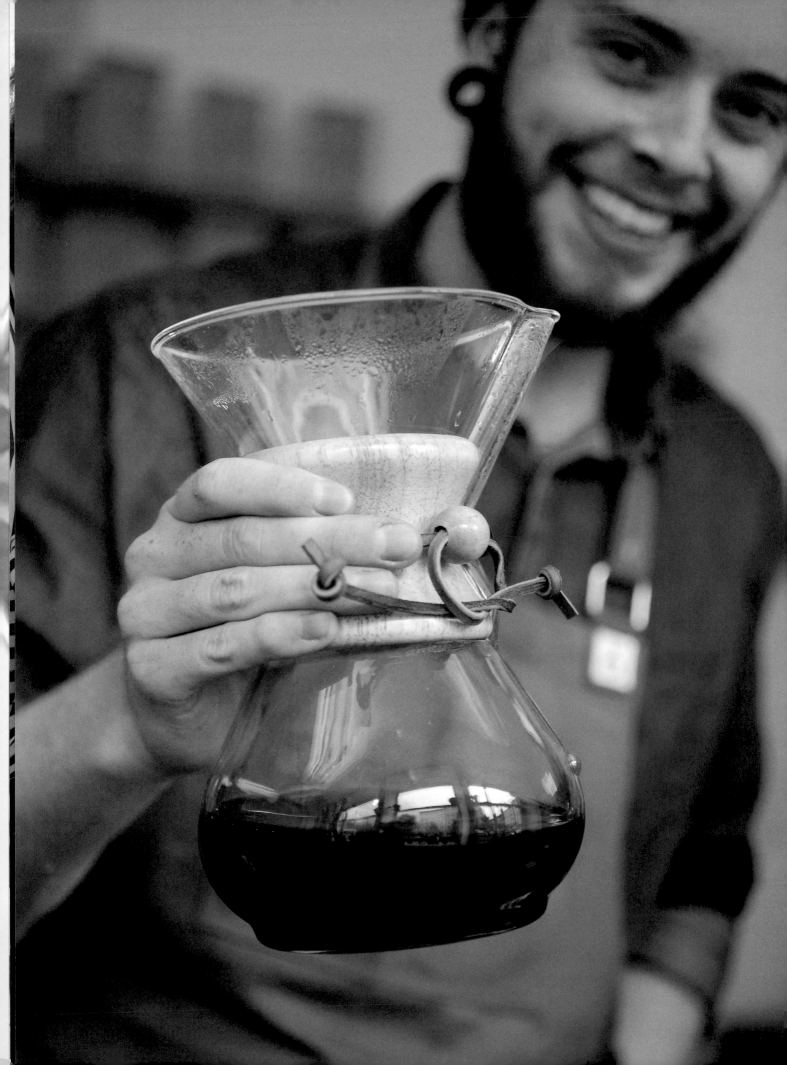

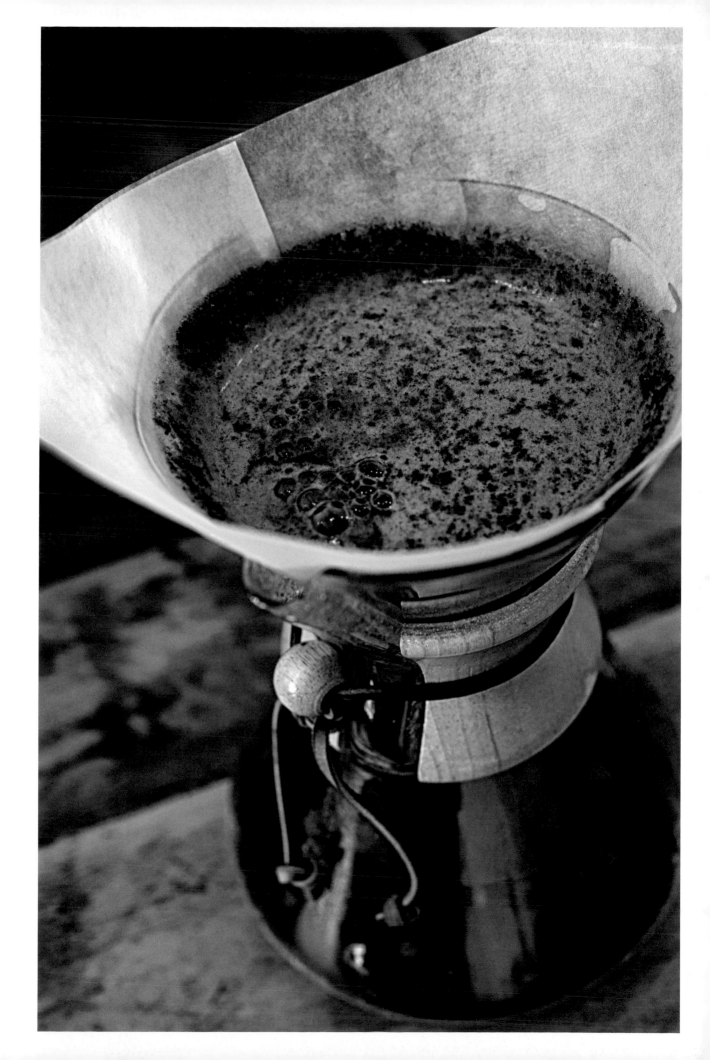

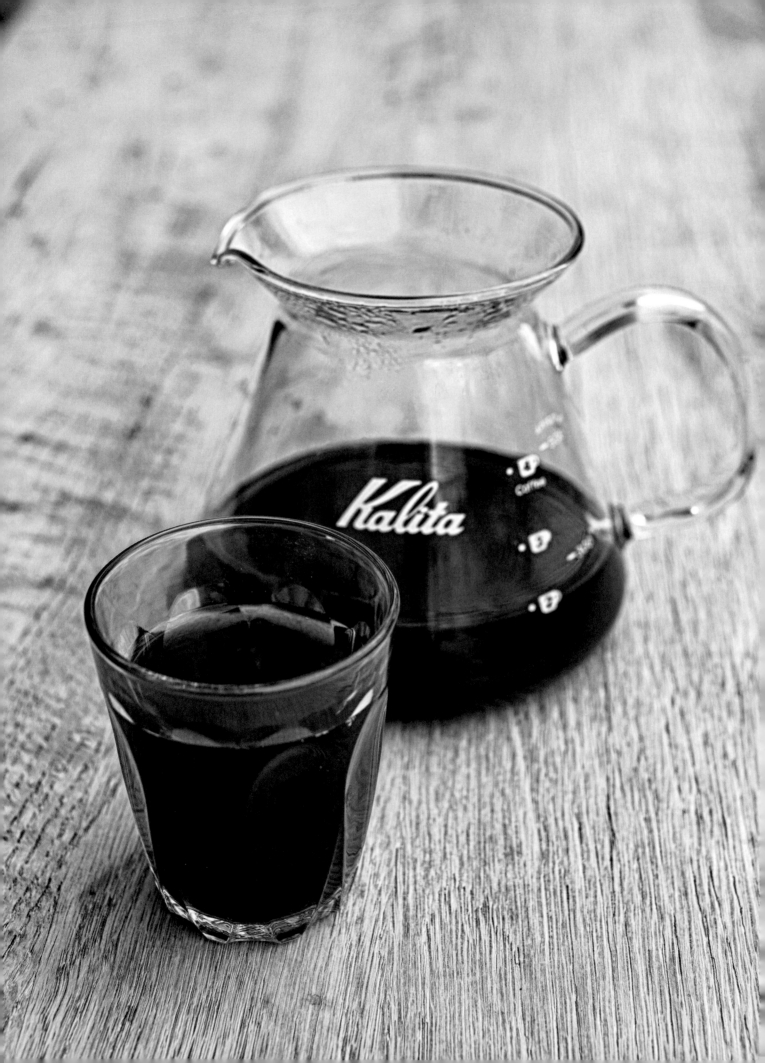

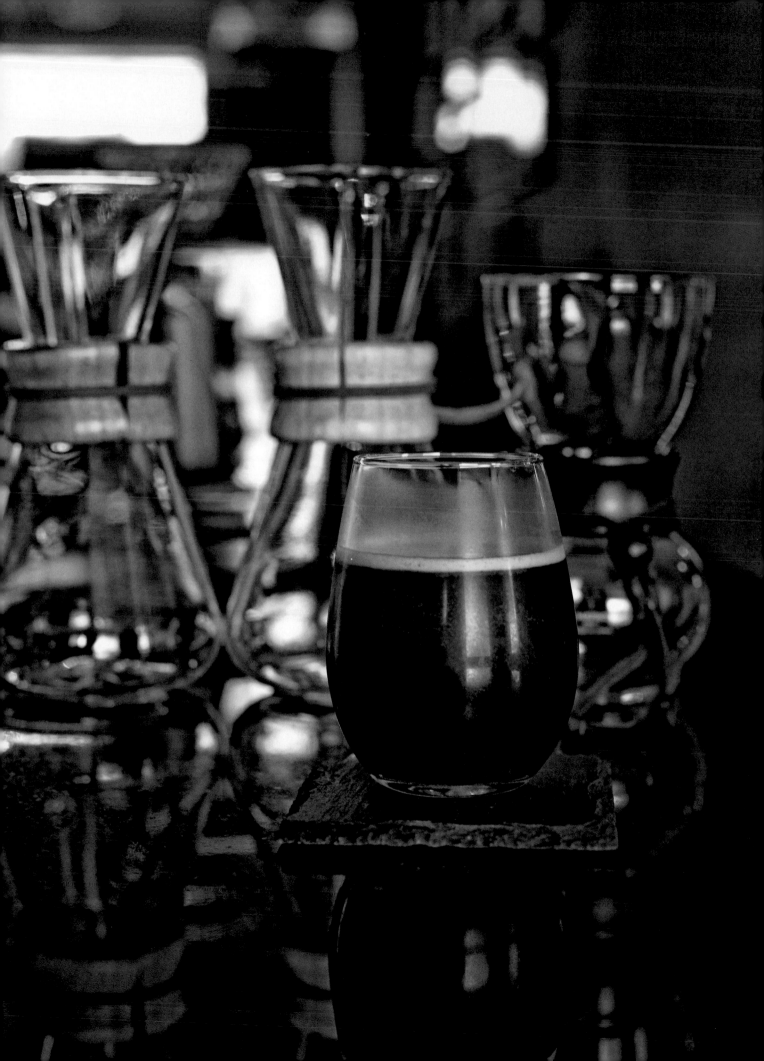

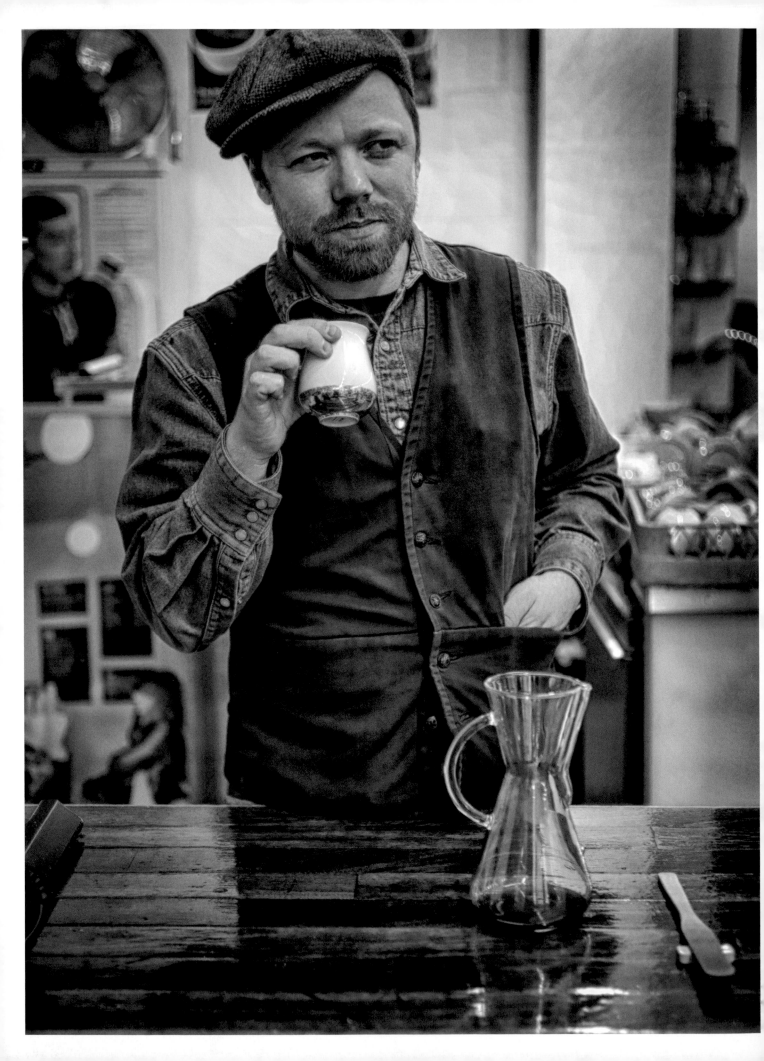

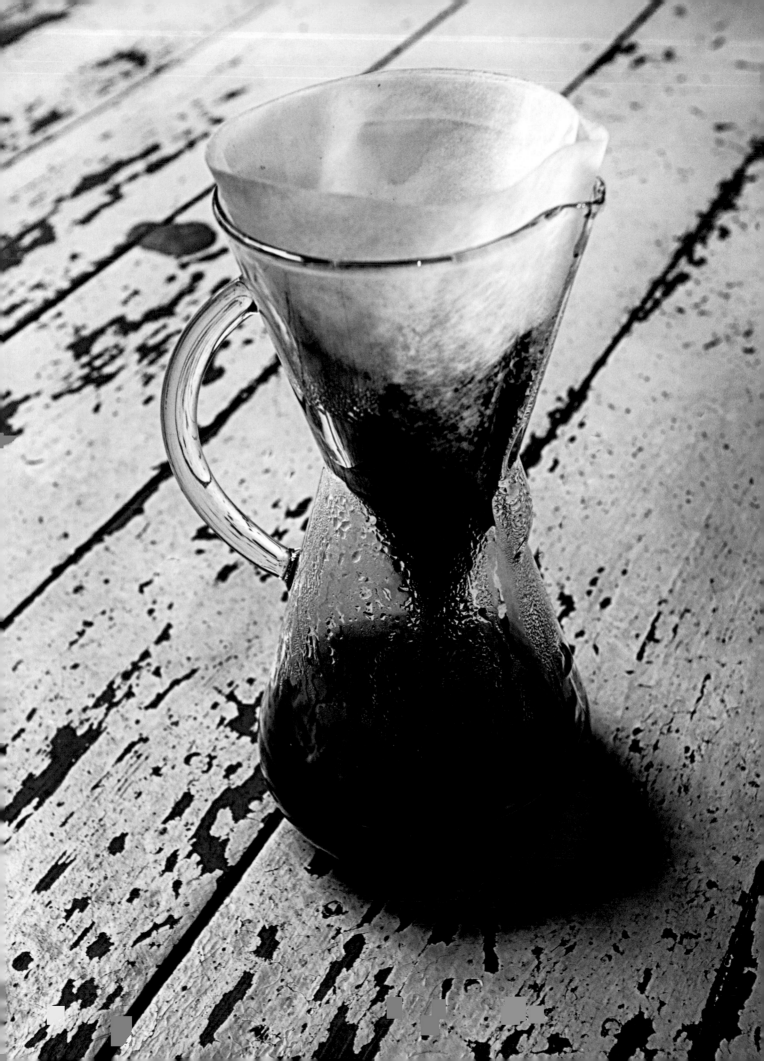

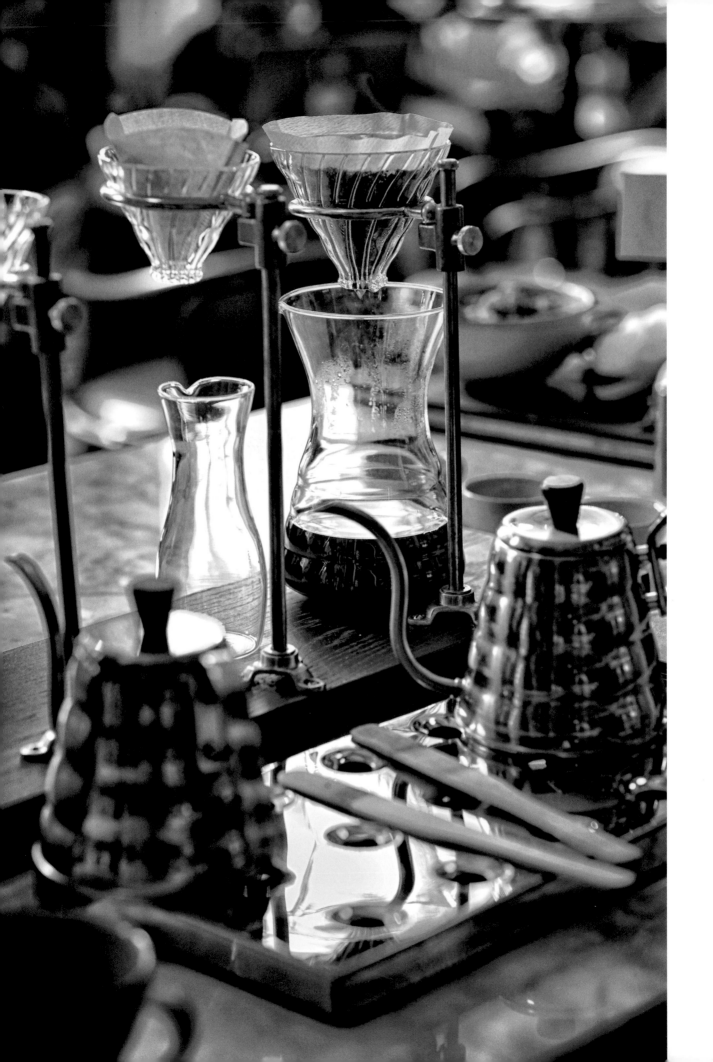

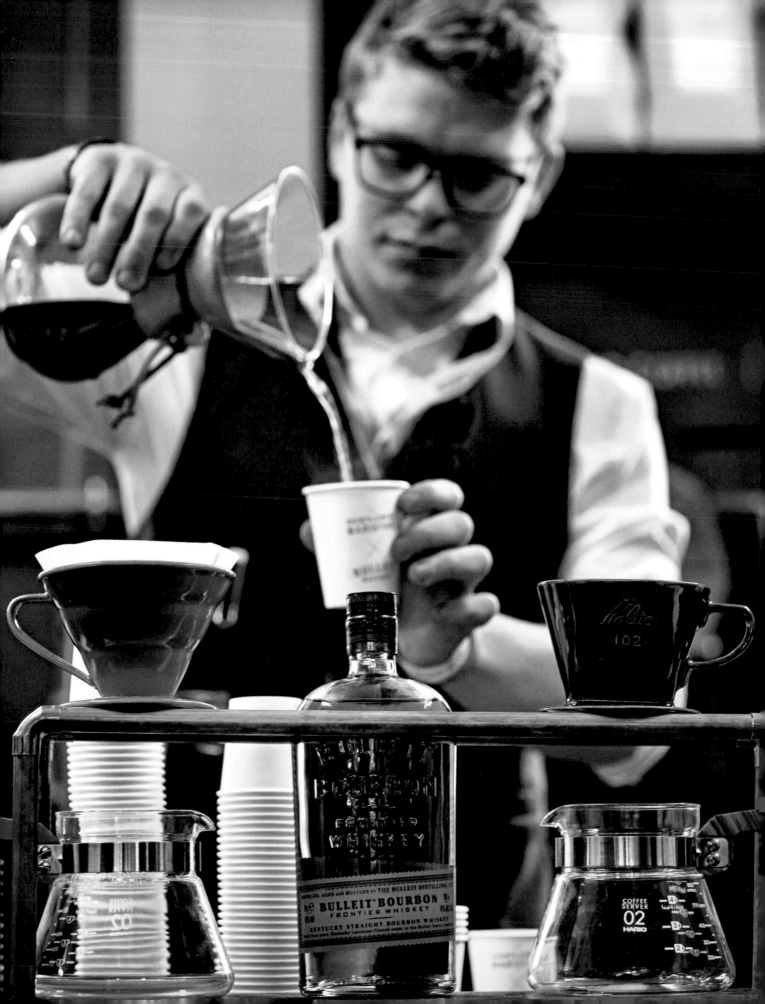

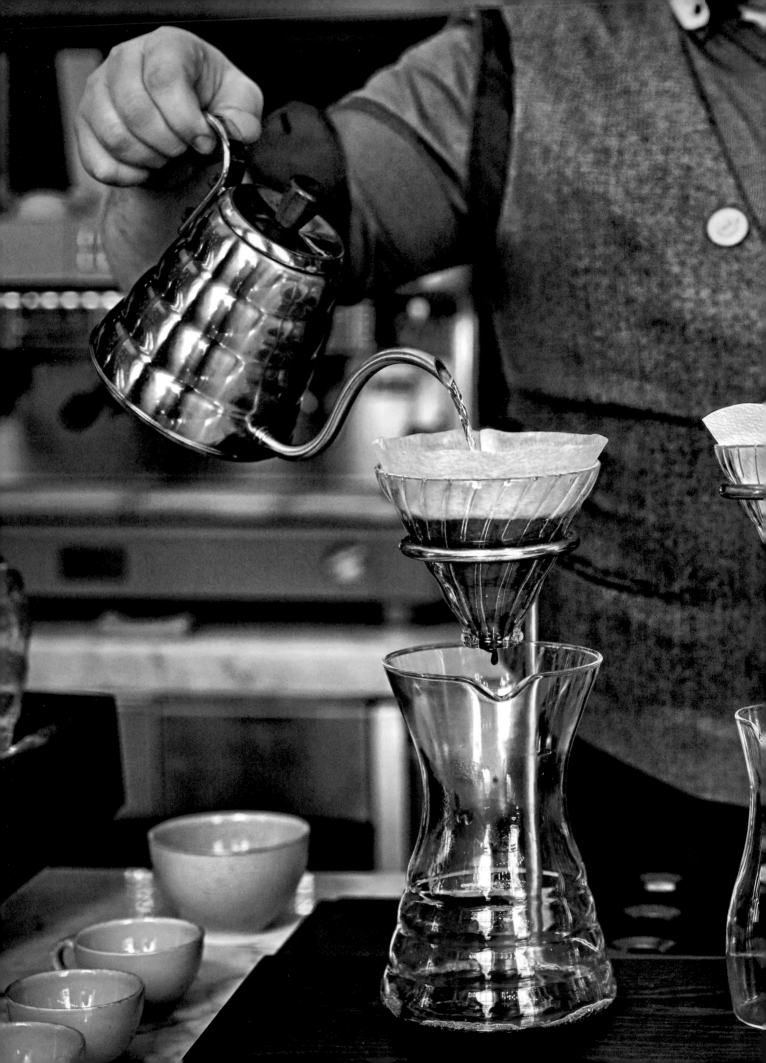

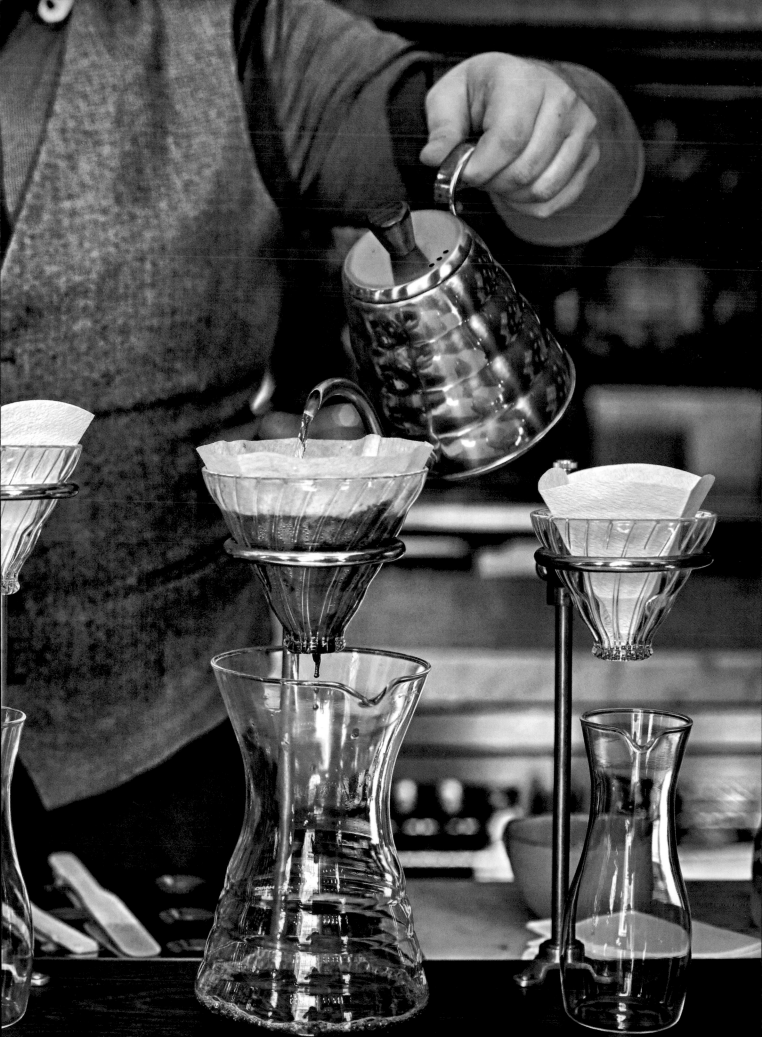

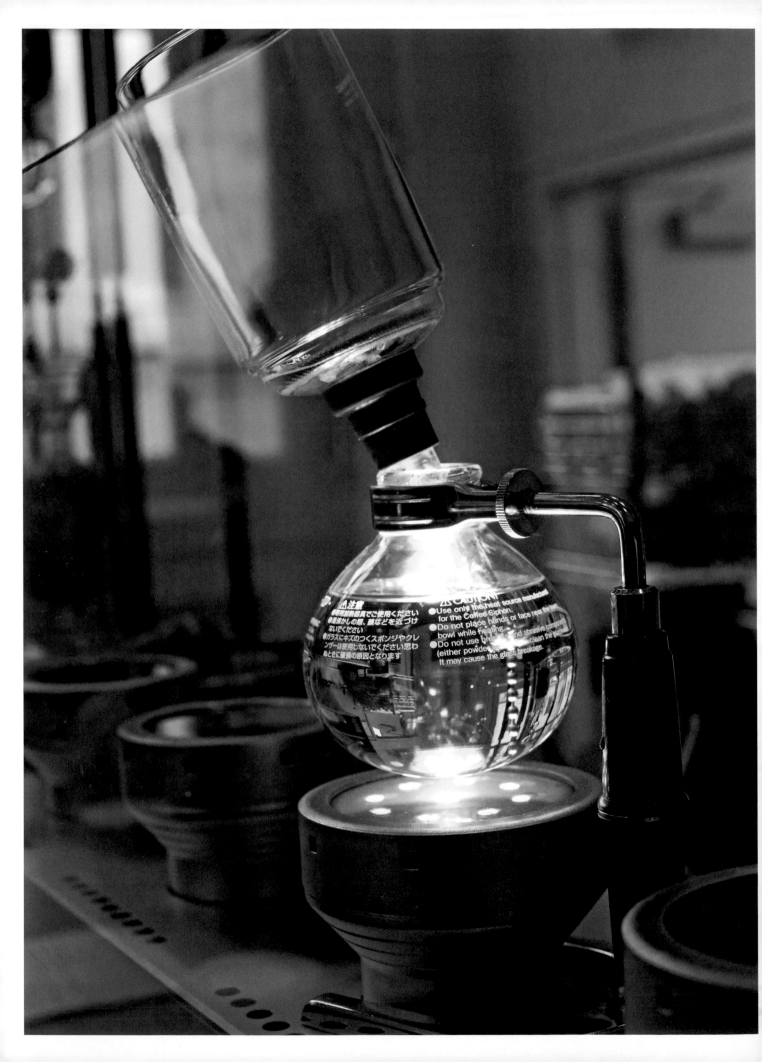

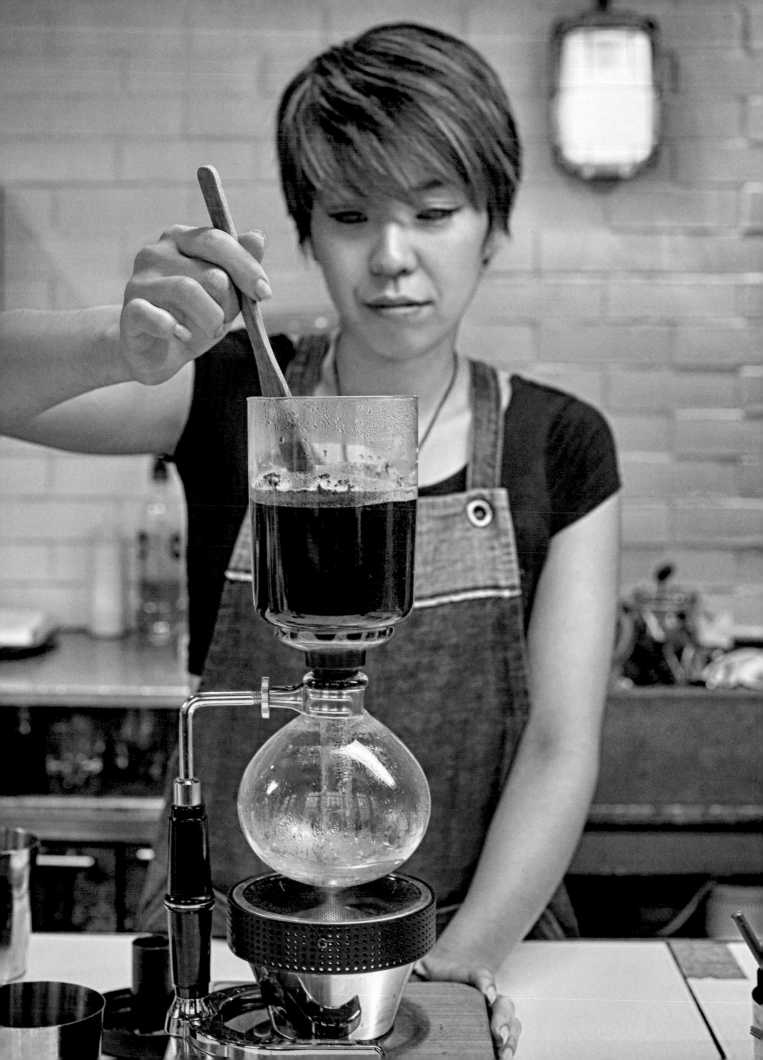

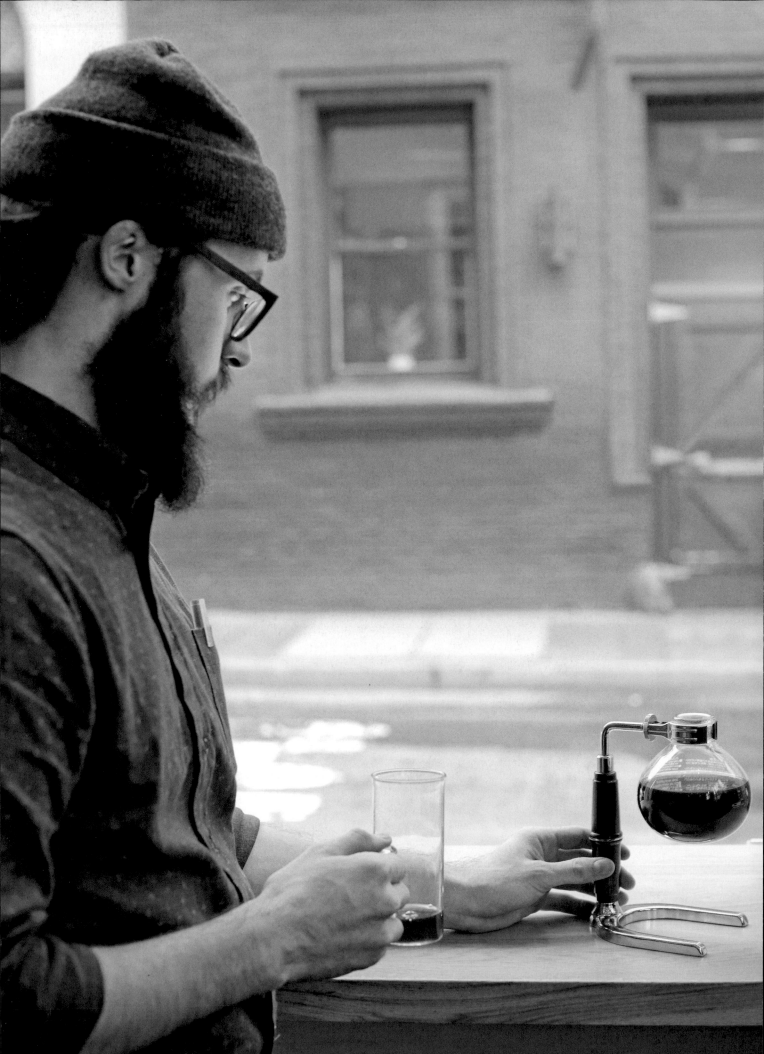

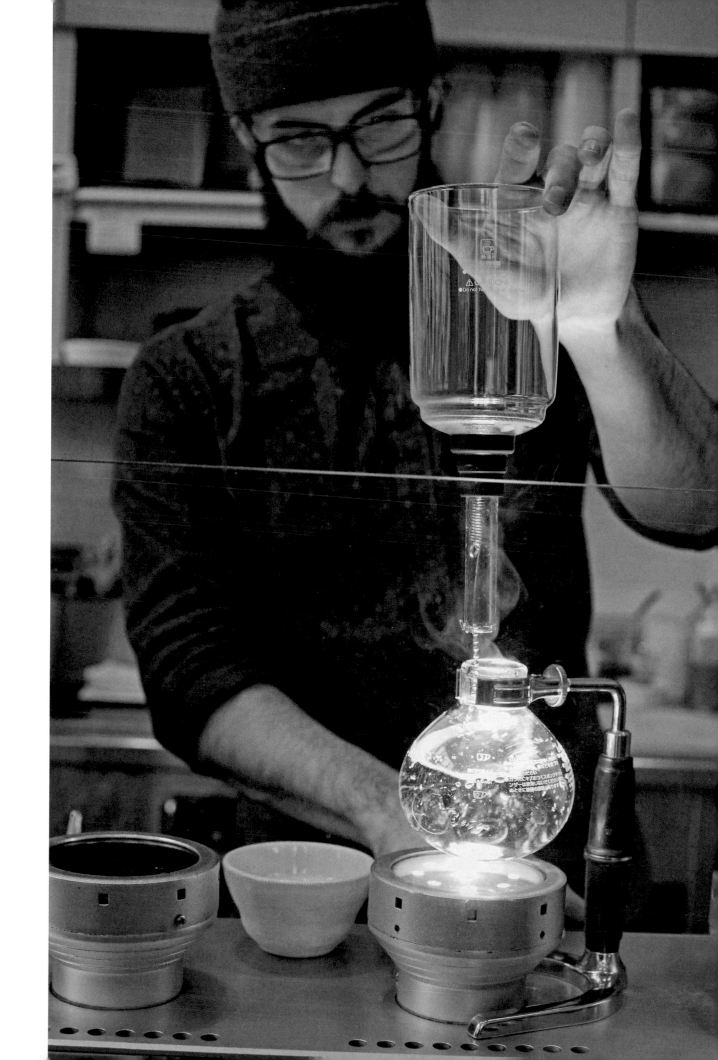

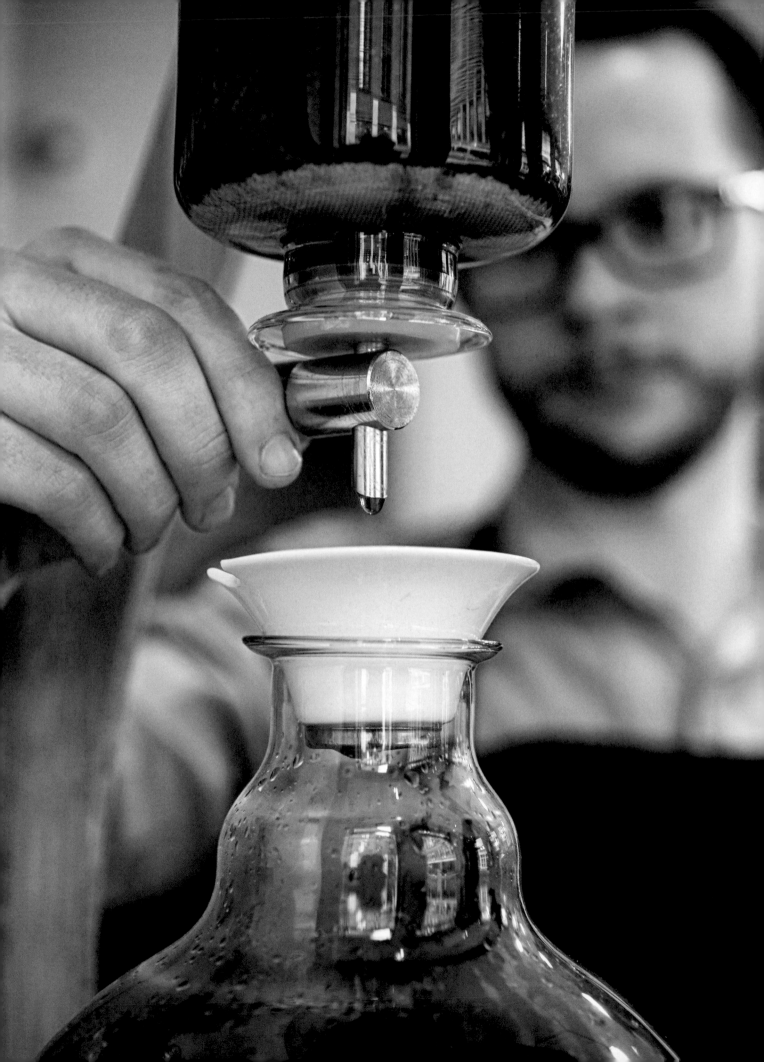

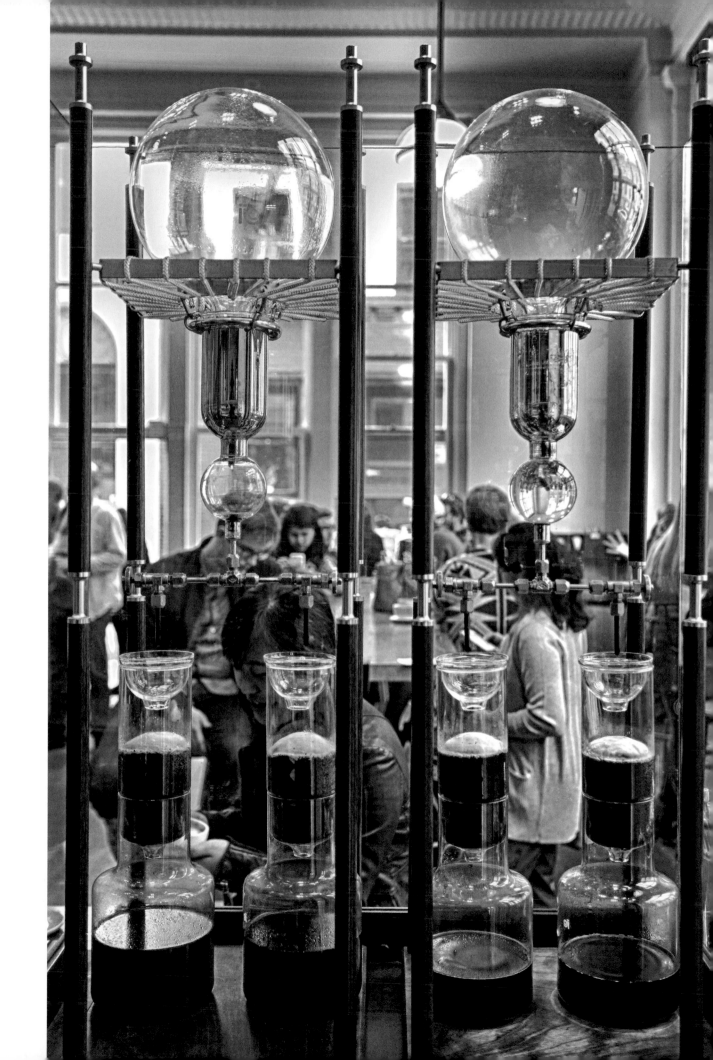

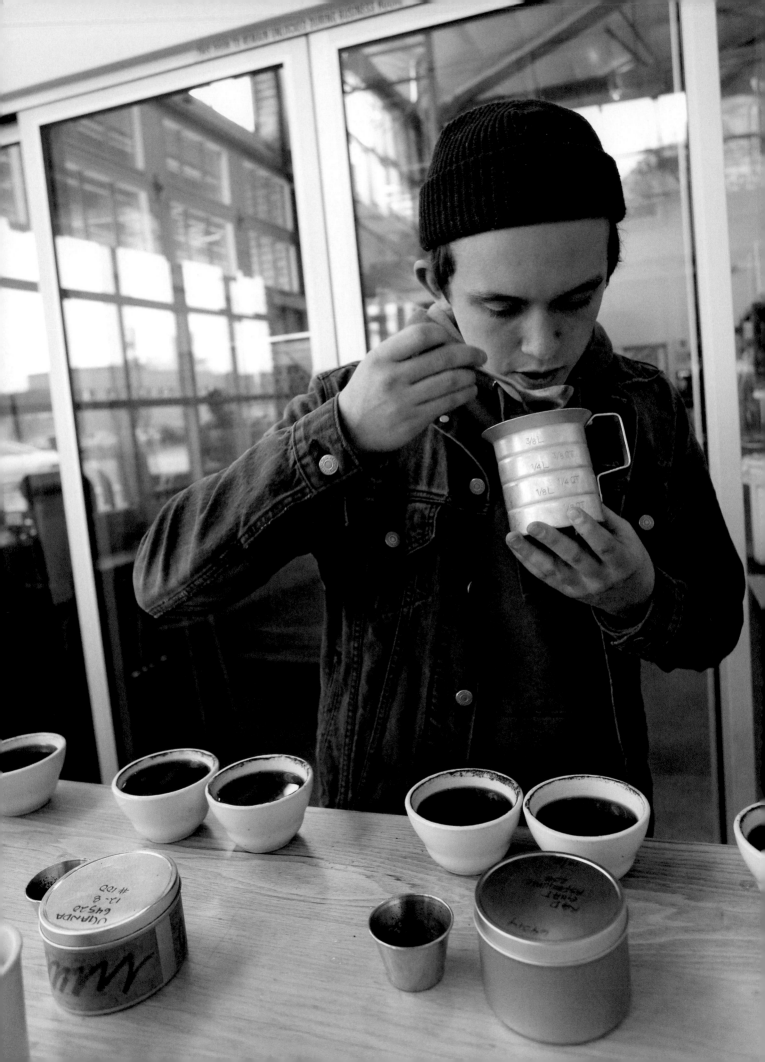

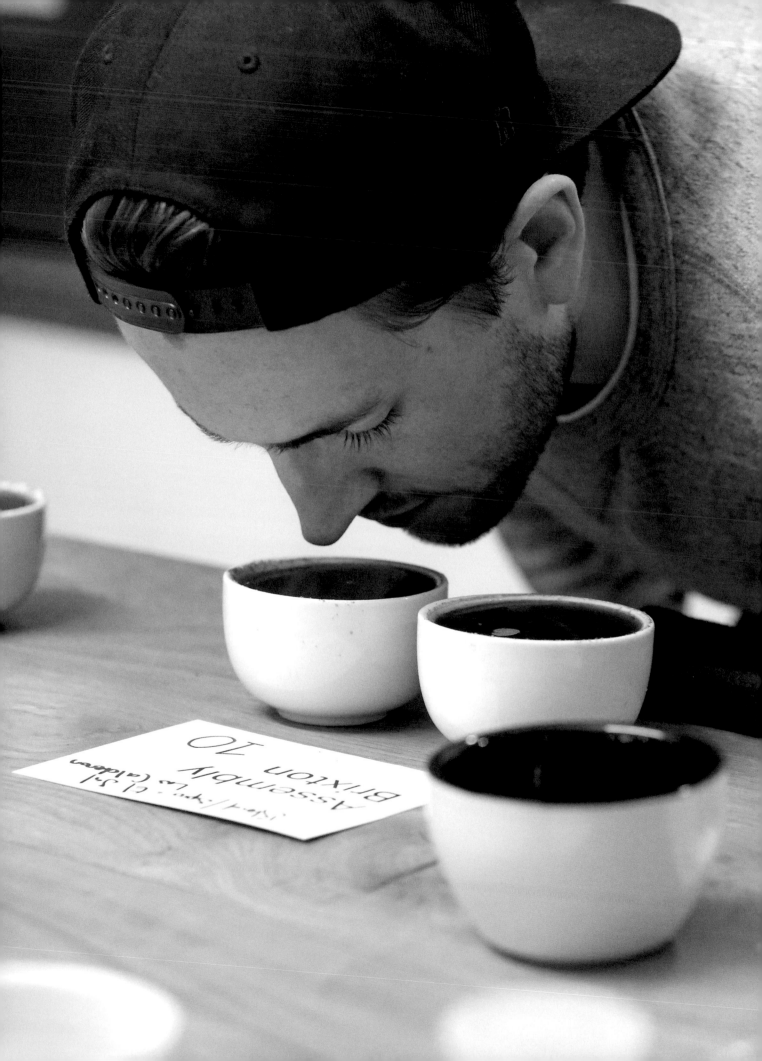

Assembly
Brixton 70

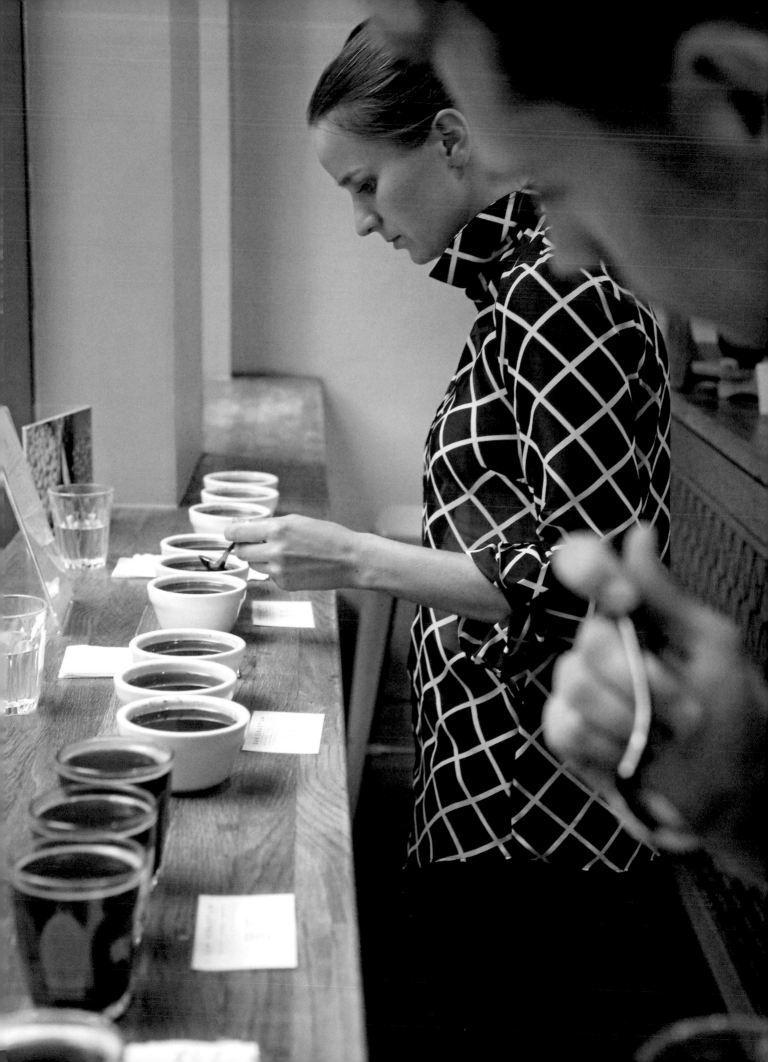

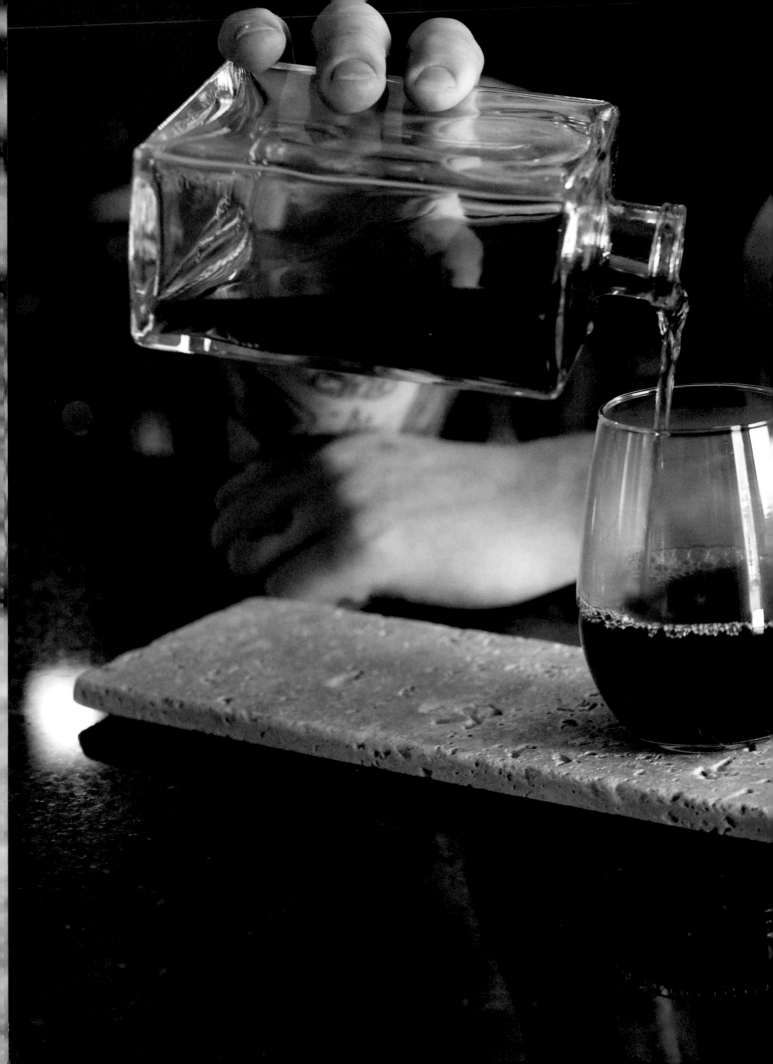

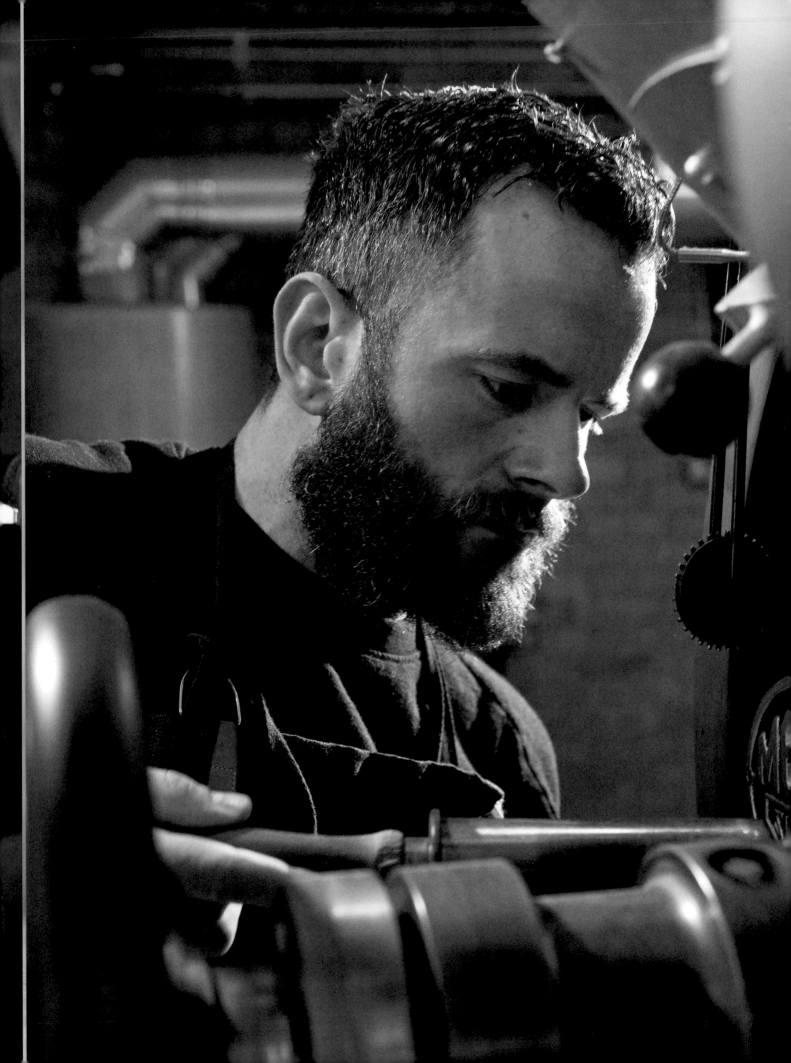

BREAKING GOOD

BEANS AND BEYOND

At the heart of any good coffee are the beans. Specialists
roast them ever so gently so we may discover their
inherent flavours, and perhaps take a special story
back home with us.

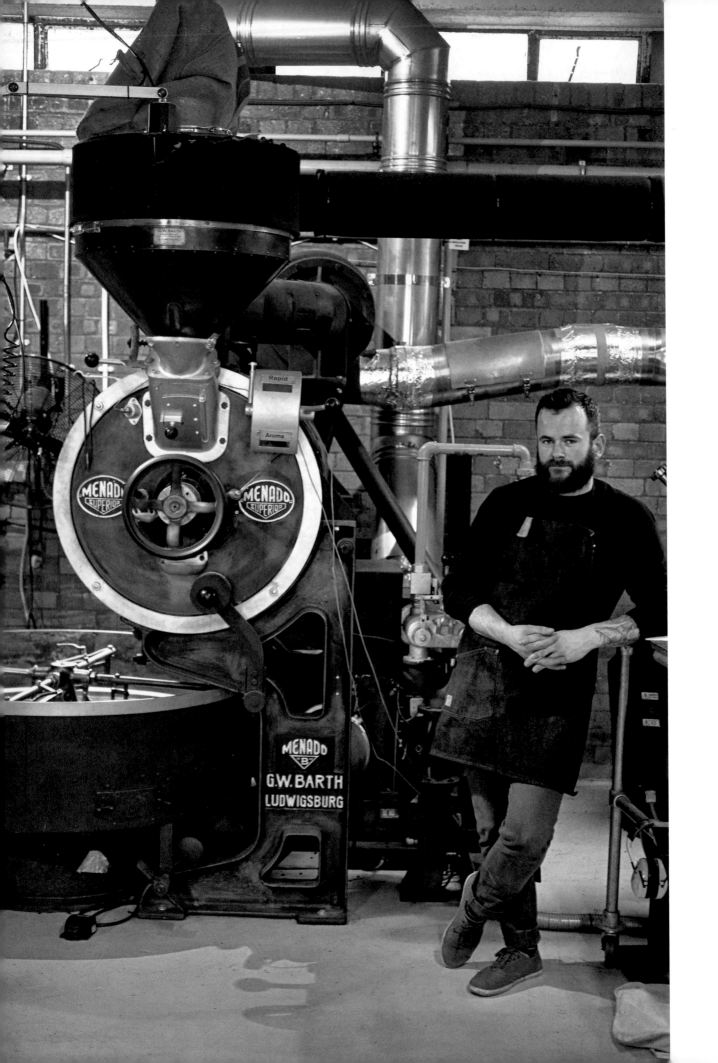

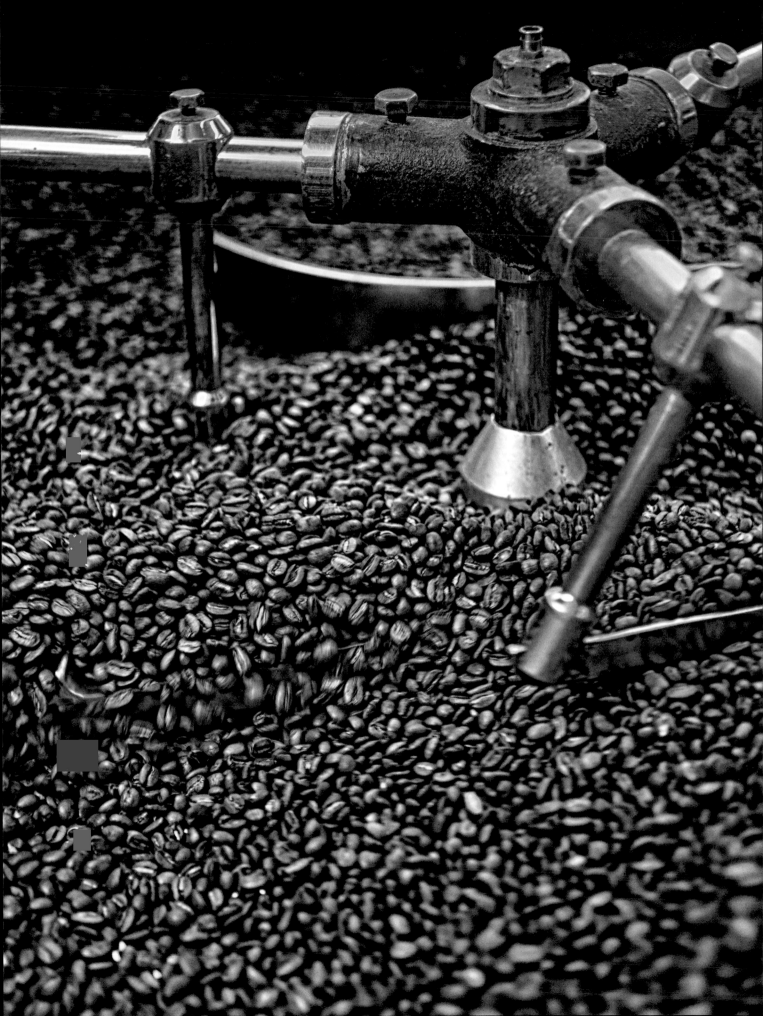

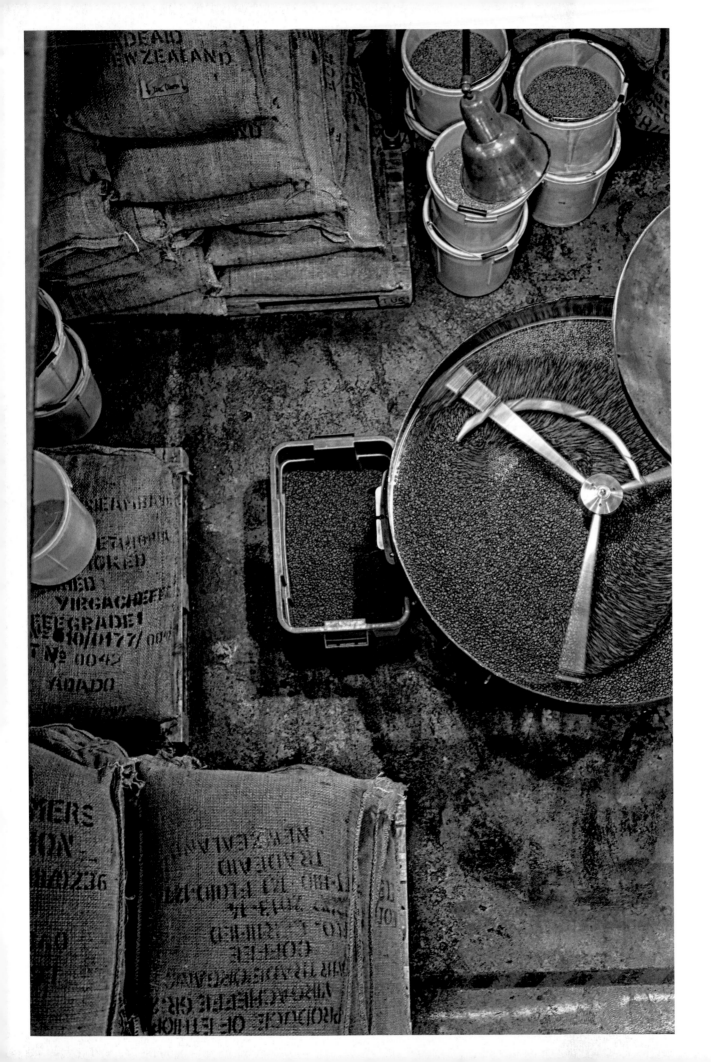

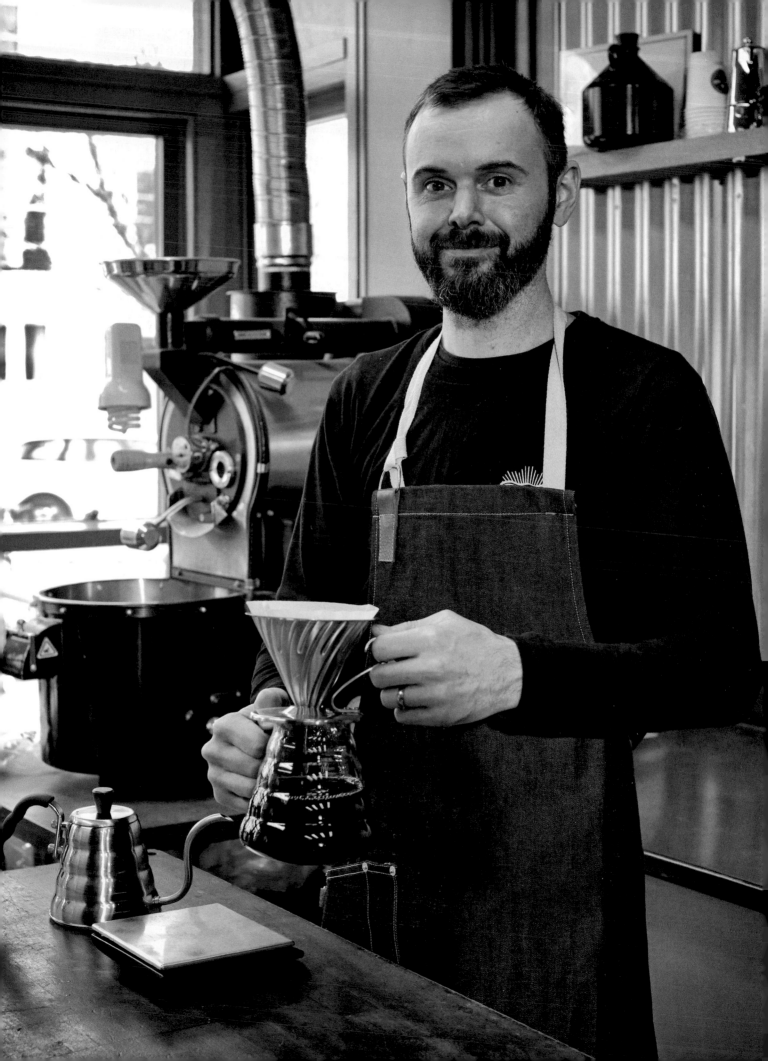

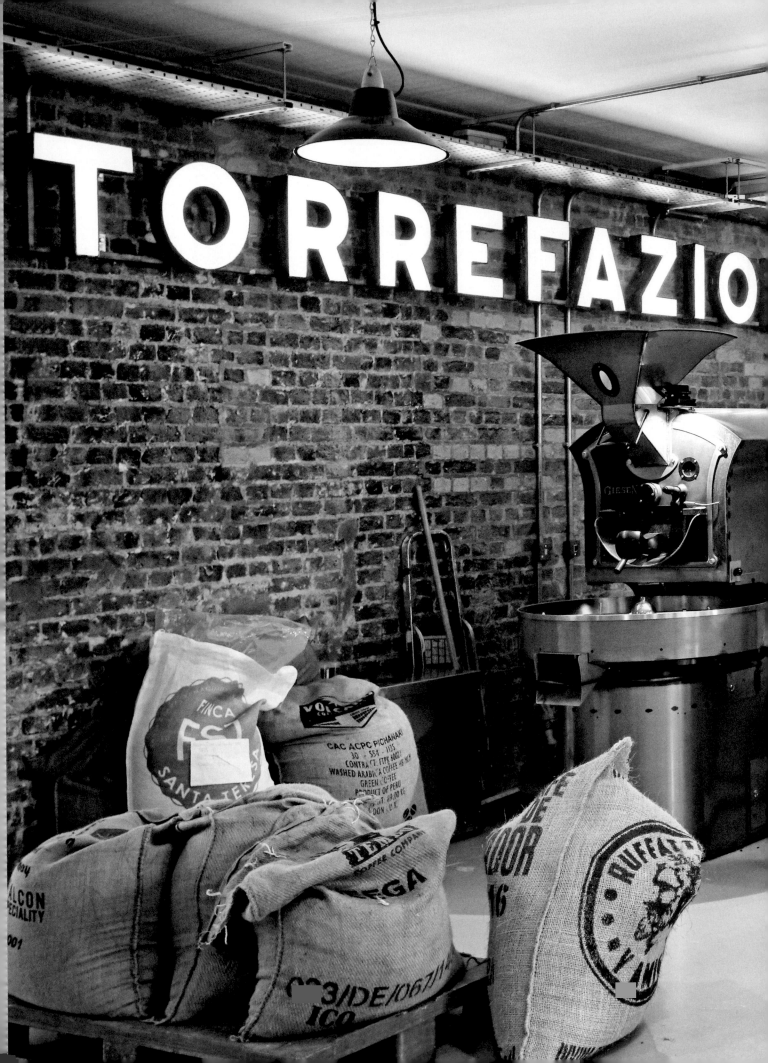

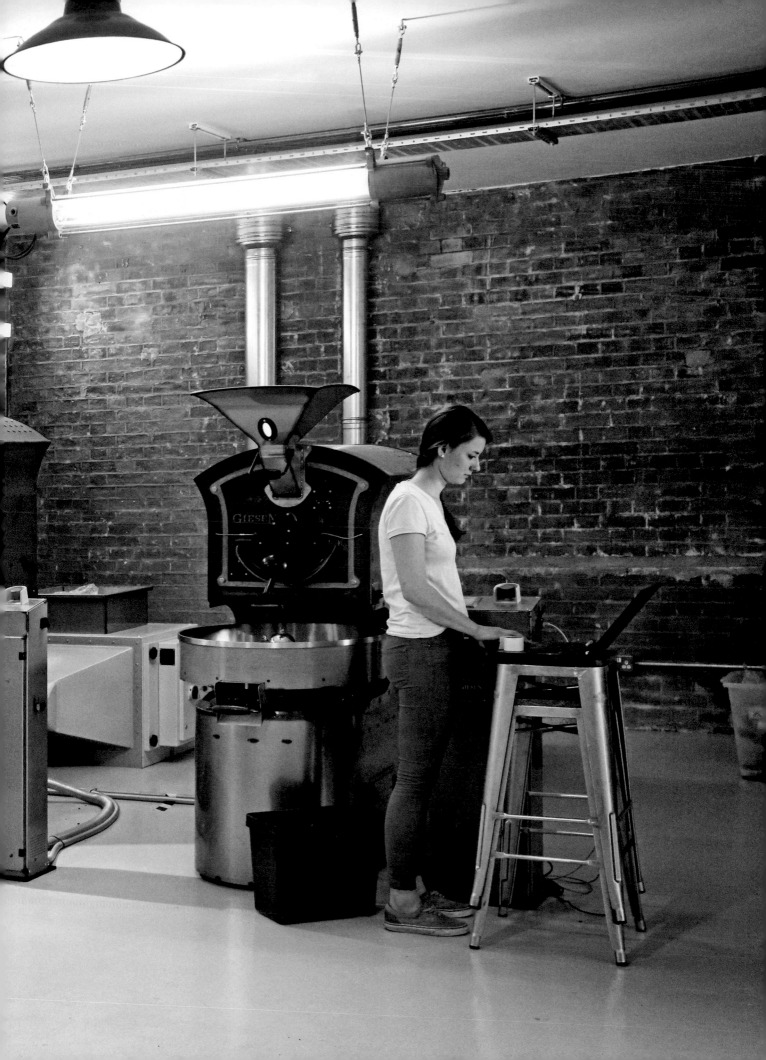

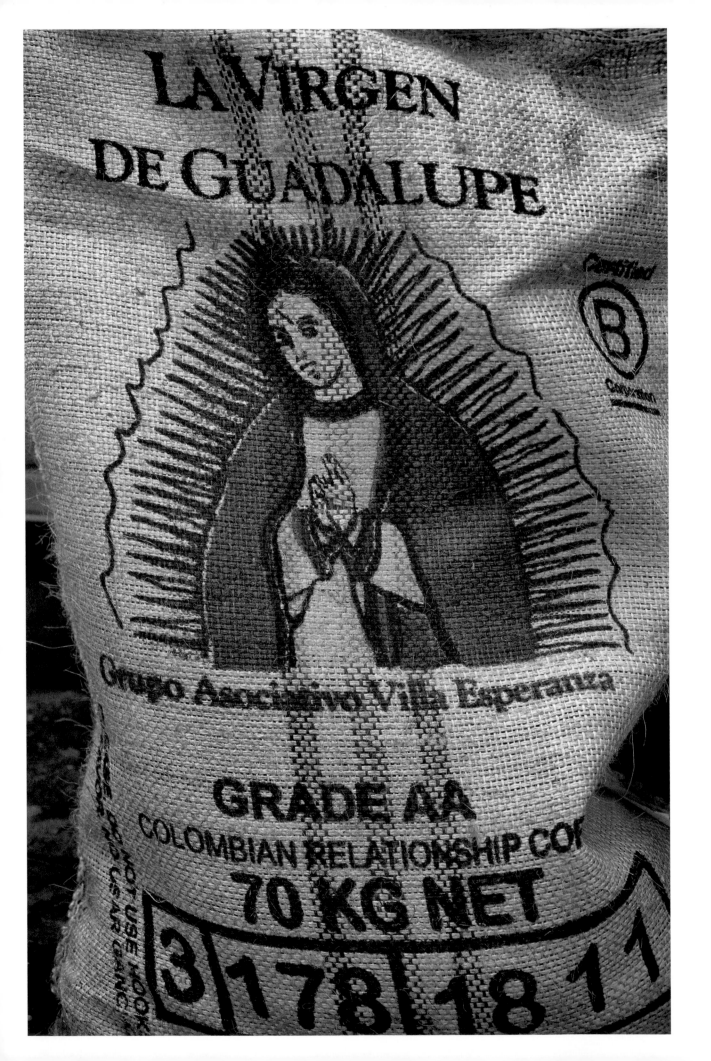

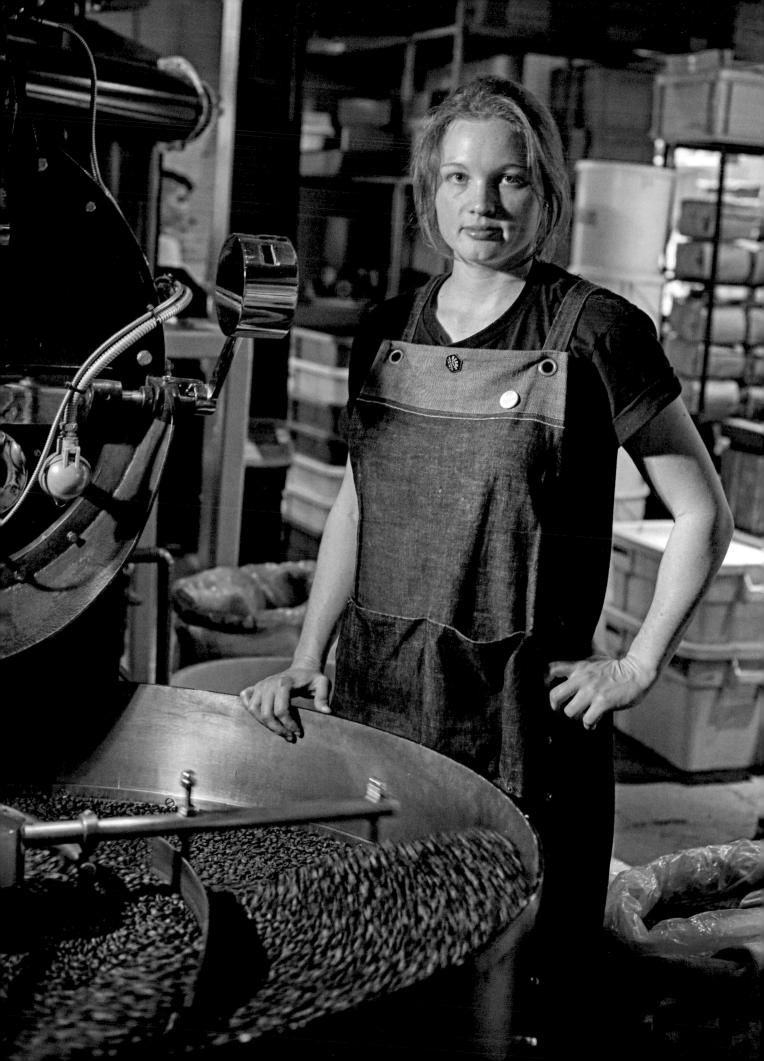

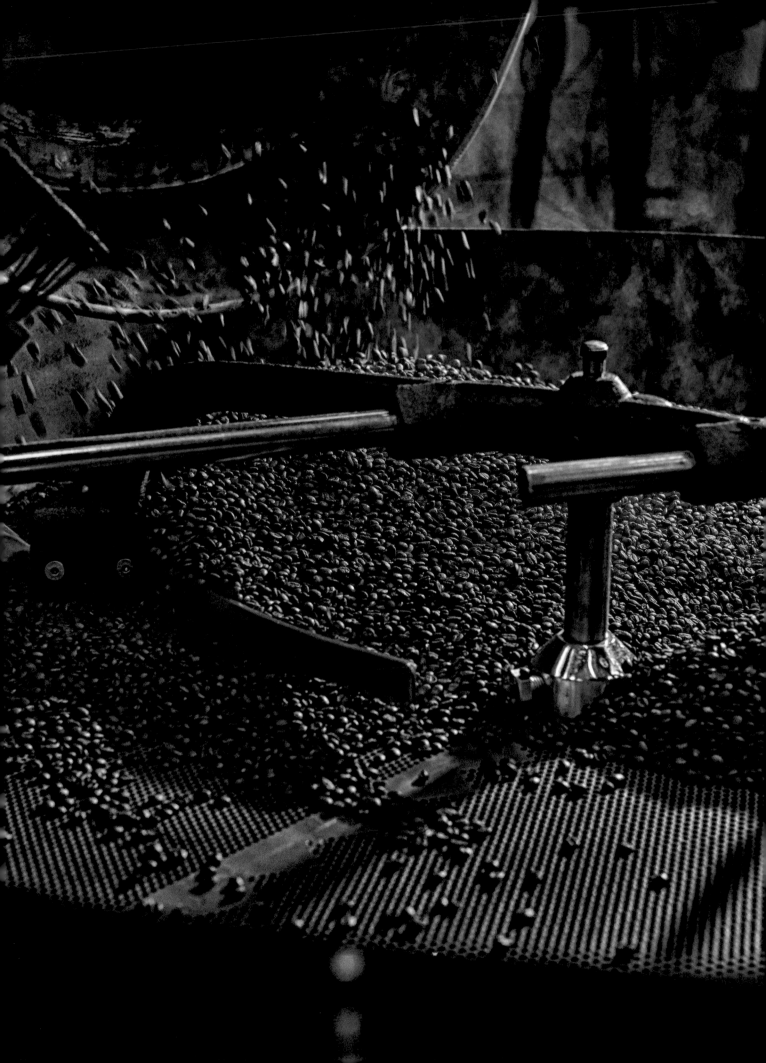

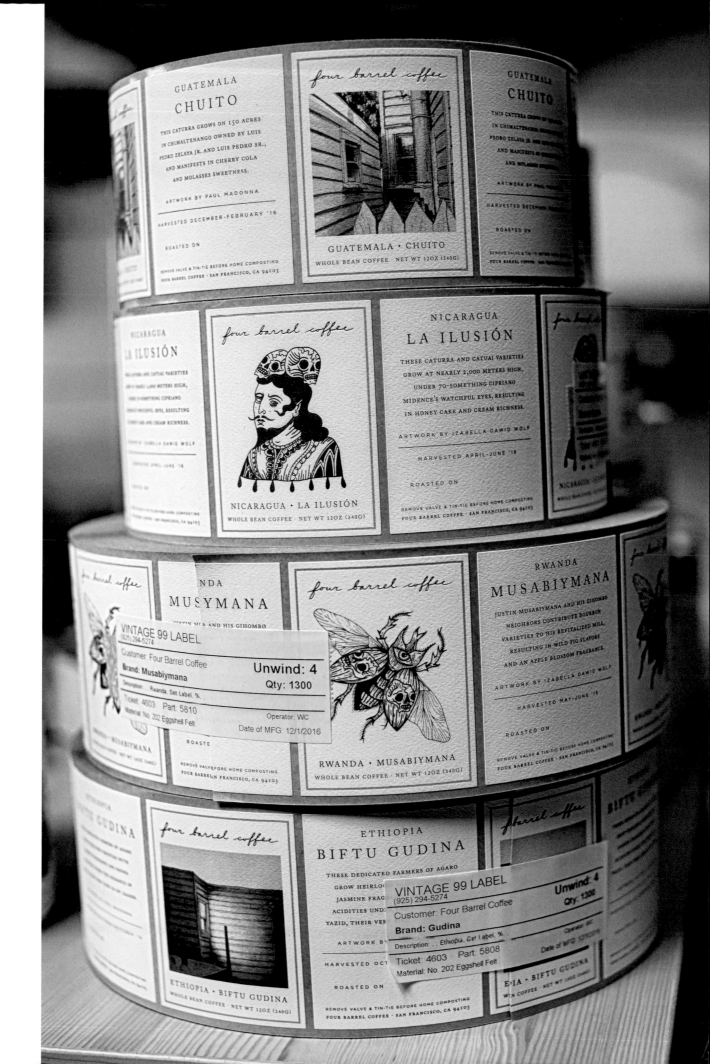

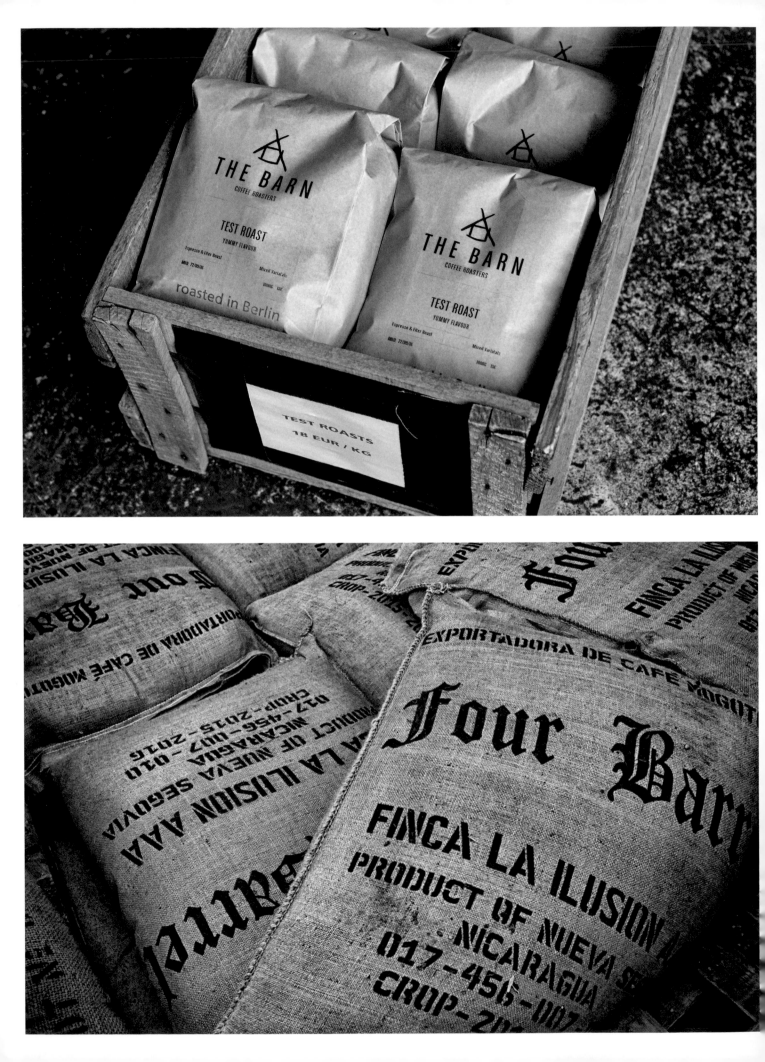

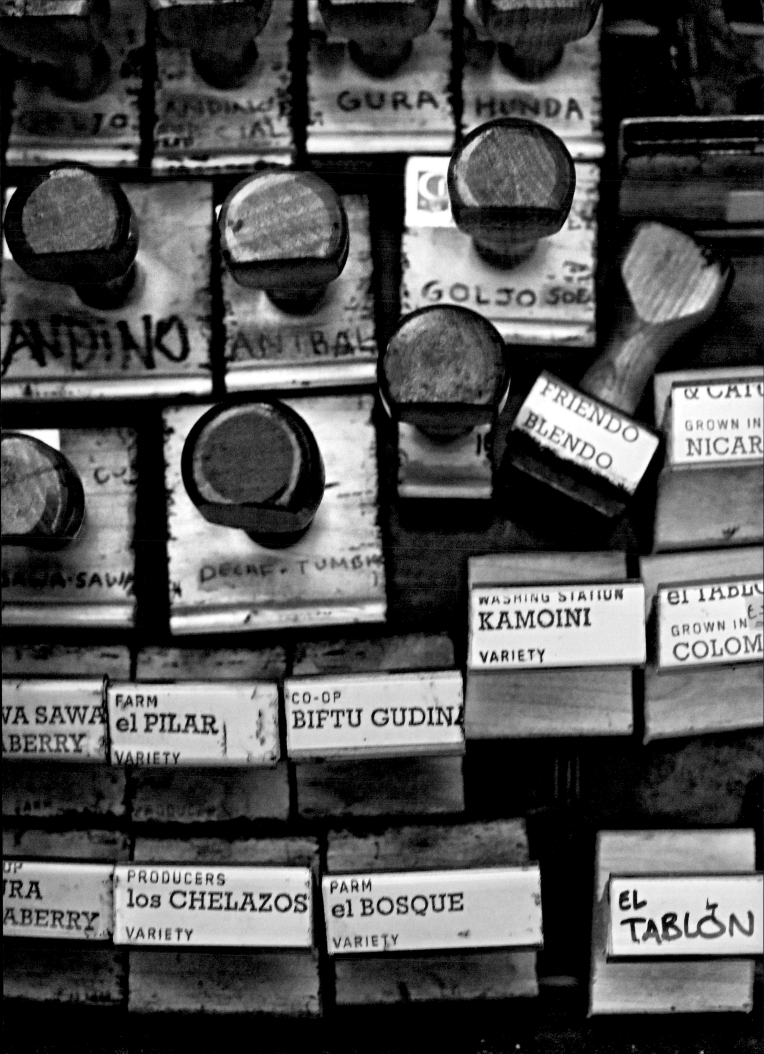

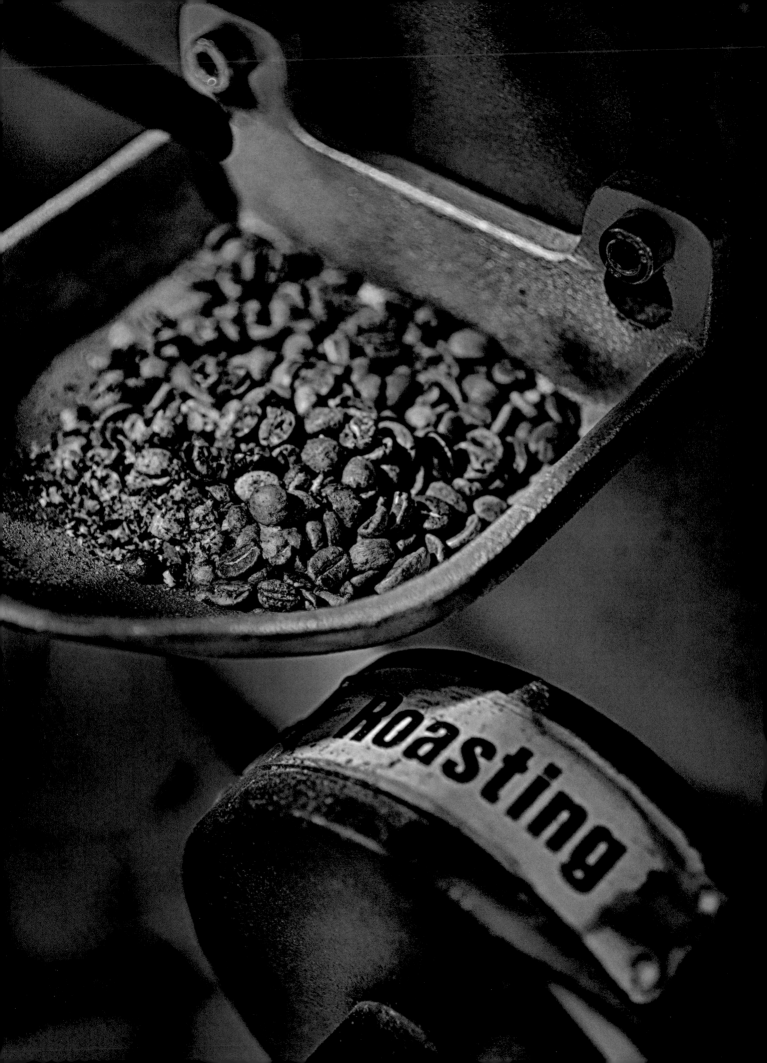

HORST A. FRIEDRICHS

Internationally renowned photographer Horst A. Friedrichs was born in Frankfurt in 1966. He studied photography in Munich and has worked as a freelance photojournalist for a number of publications including *The New York Times, Geo* and *Stern.* In 2008, he received the prestigious Lead Award for Best Reportage Photography of the Year. He has published numerous books including the best-selling *I'm One: 21st Century Mods, Or Glory: 21st Century Rockers, Cycle Style, Drive Style, Denim Style* and *Best of British* (all published by Prestel). He lives in London.

LARS HARMSEN

Lars Harmsen of Melville Brand Design in Munich teaches typography and design at the University of Applied Sciences and Arts in Dortmund. The focal point of his work is typography, corporate and editorial design. Harmsen is the author of numerous publications on design. His work has received many national and international awards and he is a frequent speaker at design conferences all over the world.

ACKNOWLEDGEMENTS

This book could not have been realized without the enthusiasm and support of the following people: Andrea Whittaker from *Der Spiegel;* Dagmar Seeland from *Stern;* Onny from Volcano Coffee Works; Sof and Jo from Story Coffee; Nia and Jack of Esters; Rachid from Aniis; Mathias and Carla from Holy Cross Brewing Society; Matthias and Julian from Hoppenworth & Ploch; Ed and Henry from The Gentlemen Baristas; Felicity, Gary, Sang Ho and James from Square Mile Coffee Roasters; Jeremy from Prufrock Coffee; Karlheinz from Coffee Star; Luke, Hugh and Laura from Sandows; Chris and Tommy from Embassy East; Peter from Kaffeine; Westy and Jeremy from Union Hand-Roasted Coffee; Oli from Mahlkönig; Yumi and Kiduk from Bonanza; Ralf from The Barn; Walter Konnik; Norton from Paymaster Garment & Stuff; Detlef from Detline Leatherworks; Kelly and Scott from Dawson Denim; Gert from Bronko; Lain from Freefall Tattoo; Manami and Dave from Hario: Brewed by Hand; Simon from The Dynamo; Alex and Rapolas from Black Box and Studio 74 by Michiko Koshino; Adam from Faraday Bikes; and Karen Mason, Maja, Ian and Guy.

My sincere gratitude also goes to Jeffrey Young from Allegra, Michael Cleland from Assembly Coffee London, and Paul Kelly from La Marzocco UK for their considerable help in taking me into the world of coffee.

A very special thanks goes to Piero Bambi and the team of La Marzocco for their invaluable contributions and inspiration.

I would also like to thank Peter Schneider, CEO of Messe Bremen and Gastro Ivent, for all his help and support. And a thank you also to the wonderful Christian and Ansgar from Kaffeeplan.

My publisher Prestel has made this a great experience and a deeply satisfying creative undertaking, with my editor Curt Holtz and the contributions of Christian Rieker, Stella Sämann, Corinna Pickart, Pia Werner, Andrew Hansen and Oliver Barter.

A special thanks to my wife Adriana and my two daughters Greta and Zoe, for their love, faith and inspiration.

I would also like to thank Prof. Lars Harmsen from Melville Brand Design, who created the book's concept and design, for his generous work, tremendous enthusiasm and never-ending creativity. His input while making this book and his enduring friendship are invaluable to me.

From the author Nora Manthey: This is for my sister Frauke, who made her dream of coffee come true and continues to dare. My gratitude belongs to the many cafés and makers engaged in deliciousness all over the world – you are a source of inspiration.

LOCATIONS

Alchemy Coffee, London – *alchemycafes.co.uk*
Allpress, London – *allpressespresso.com*
Andytown Coffee Roasters, San Francisco – *andytownsf.com*
Aniis, Frankfurt – *aniis.de*
The Archery Front, San Francisco – *thearcherysf.com*
The Barn, Berlin – *thebarn.de*
Belleville Brûlerie, Paris – *cafesbelleville.com*
Bicycle Coffee Co., Oakland – *bicyclecoffeeco.com*
Black Crow Coffee, Worthing, UK
Blue Bottle Coffee, Oakland – *bluebottlecoffee.com*
Bonanza Coffee Roasters, Berlin – *bonanzacoffee.de*
Bulldog Edition at Ace Hotel, London
Bunka, Frankfurt – *bunca.de*
Café Pinson, Paris – *cafepinson.fr*
Caravan, London – *caravanrestaurants.co.uk*
Coffee Star, Berlin – *coffeestar.eu*
Cream, London – *cream-shoreditch.com*
The Curator Cafe, Totnes, UK – *italianfoodheroes.com*
Curators Coffee, London – *curatorscoffee.com*
Cutie Pie Café, Berlin – *cutiepie-berlin.de*
Ditta Artigianale, Florence – *dittaartigianale.it*
The Dynamo, London – *the-dynamo.co.uk*
Embassy East, London – *embassyeast.co.uk*
Esters, London – *estersn16.com*
Five Elephant, Berlin – *fiveelephant.com*
Four Barrel Coffee, San Francisco – *fourbarrelcoffee.com*
Front, San Francisco – *frontsf.com*

The Gentlemen Baristas, London – *thegentlemenbaristas.com*
The Holy Cross Brewing Society, Frankfurt – *theholycross.de*
Kaffeine, London – *kaffeine.co.uk*
Kioskafé, London – *kioskafe.com*
Lantana, London – *lantanacafe.co.uk*
Look Mum No Hands, London – *lookmumnohands.com*
Macintyre Coffee, London – *macintyrecoffee.co.uk*
Nomad Coffee Roasters, Barcelona – *nomadcoffeeroasters.com*
Ozone Coffee Roasters, London – *ozonecoffee.co.uk*
Prufrock Coffee, London – *prufrockcoffee.com*
Rapha Cycle Club, London – *rapha.cc*
Ritual Coffee, San Francisco – *ritualroasters.com*
The Roasting Party, Winchester, UK – *theroastingparty.co.uk*
Round Hill Roastery, Somerset – *roundhillroastery.com*
Saint Frank Coffee, San Francisco – *saintfrankcoffee.com*
Sandows, London – *sandows.com*
Satan's Coffee Corner, Barcelona – *satanscoffee.com*
Small Batch Coffee Roasters, Brighton – *smallbatchcoffee.co.uk*
Square Mile Coffee Roasters, London – *squaremilecoffee.com*
Story Coffee, London – *storycoffee.co.uk*
Timberyard, London – *timberyard.co*
Trouble Coffee & Coconut Club, San Francisco – *troublecoffeeco.com*
Union Hand-Roasted Coffee, London – *unionroasted.com*
Volcano Coffee Works, London – *volcanocoffeeworks.com*
Workshop Coffee, London – *workshopcoffee.com*

ORGANIZATIONS AND COMPANIES

AeroPress – *aerobie.com/product/aeropress/*
Ceni Cafe – *cenicafe.org*
Dawson Denim – *dawsondenim.com*
Faraday Bicycles – *faradaybikes.com*
Gastro Ivent – *gastro-ivent.de*
Hario: Brewed by Hand – *hario.jp*

La Marzocco – *lamarzocco.com*
Laird Hatters – *lairdlondon.co.uk*
The London Coffee Festival – *londoncoffeefestival.com*
Specialty Coffee Association – *sca.coffee*
Velopresso LTD – *velopresso.cc*
World Coffee Research – *worldcoffeeresearch.org*

RESOURCES

Eater Animated,
How We Got To Third Wave Coffee (video), 2016
Ritual Coffee Roasters, *Brew Book*, 2016
James Hoffmann, *World Atlas of Coffee*, 2014
Brandon Loper, *A Film About Coffee*, 2014
Matthew Green, *Lost World of the London Coffeehouse*, 2013

Kenneth Gergen, *Cell Phone Technology and the Challenge of Absent Presence*, 2002
Björg Brend Laird, *Coffee Awesome* (Podcast)
Merry White, *Coffee Life in Japan*, 2012
Caffeine – caffeinemag.com
Standart Magazine – standartmag.com

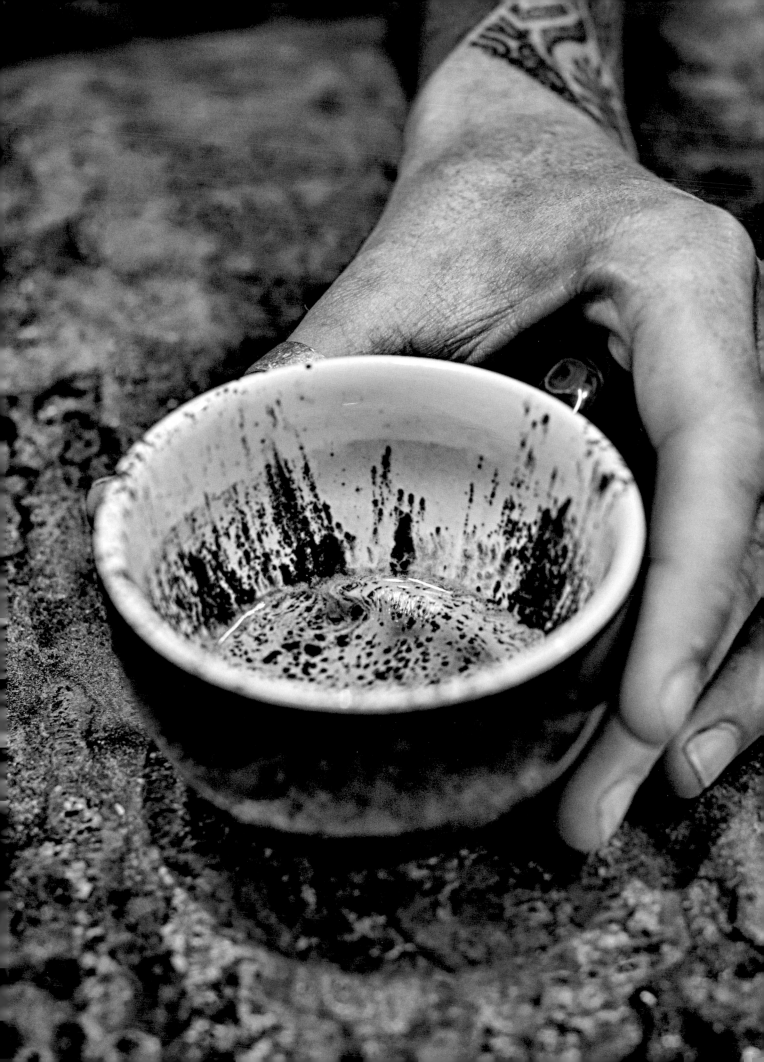

© Prestel Verlag, Munich • London • New York, 2017
A member of Verlagsgruppe Random House GmbH
Neumarkter Straße 28 • 81673 Munich

© for images Horst Friedrichs, London, 2017
© for design Lars Harmsen, Melville Brand Design,
 Munich, 2017
© for text Nora Manthey

Prestel Publishing Ltd.
14-17 Wells Street
London W1T 3PD

Prestel Publishing
900 Broadway, Suite 603
New York, NY 10003

Editorial direction: Curt Holtz & Stella Sämann
Copyediting: Jonathan Fox
Design and layout: Lars Harmsen, Melville Brand Design
Production: Corinna Pickart
Separations: Reproline Mediateam
Printing and binding: TBB, a.s., Banská Bystrica
Paper: Condat matt Périgord

Verlagsgruppe Random House FSC® N001967

Printed in Slovakia

ISBN 978-3-7913-8321-7

www.prestel.com